TOULOUSE-LAUTREC

TOULOUSE-LAUTREC
Edward Lucie-Smith

Phaidon Press Limited
Regent's Wharf, All Saints Street, London N1 9PA

First published 1977
Second edition, revised and enlarged, 1983
Reprinted 1987, 1989, 1992, 1994, 1998, 2000
© 1983 Phaidon Press Limited

A CIP catalogue record for this book is available from the British
Library

ISBN 0 7148 2761 4

Printed in Singapore

The publishers have endeavoured to credit all known persons holding
copyright or reproduction rights for the illustrations in this book.

Cover illustrations:
(front) *Woman at her Toilet* (Plate 37)
(back) *Woman with a Black Feather Boa* (Plate 10)

Toulouse-Lautrec

A few artists have found a place in the popular consciousness, not so much because of their art, but because of the legend created by their lives. Van Gogh and Gauguin are two of these, and Henri de Toulouse-Lautrec is a third. In this sense they outrank contemporaries who were equally or perhaps even more gifted, among them Degas, Monet and Cézanne. Indeed, while the latter three hold a more central position in European painting, it is the former three who have been largely responsible for creating the current popular image of the artist. There is no major film about the life of Degas, while John Houston's 1952 film-biography of Lautrec, *Moulin Rouge*, has been seen by hundreds of thousands of people, who no doubt took away from it an ineffaceable – if overdrawn – idea of the artist and the world he inhabited.

The life stories of Van Gogh and Gauguin follow a romantic pattern, and are clearly ready to serve as archetypes of the artist's relationship to society. Van Gogh ended in madness and suicide; Gauguin deliberately exiled himself from European civilisation. Their most typical paintings are statements about certain ideas and needs – in Van Gogh's case about the paramountcy of feeling, and about the duty to experience every moment as intensely as possible, whatever the consequences; and in Gauguin's about the thirst for the primitive, which has since exercised so great an influence upon twentieth-century artists. Lautrec's position is different. His life story is hardly one with which the ordinary individual can identify. Though it is a tragedy, it is one without universal application. The secret of his appeal must be looked for elsewhere.

Lautrec was born on 24 November 1864, in Albi. His full name was Henri-Marie-Raymond de Toulouse-Lautrec, and he belonged to one of the most ancient families in France, that of the medieval Counts of Toulouse. His parents were cousins, and were ill-suited to one another. His mother, Countess Adèle, pious, intelligent and virtuous, would have liked a peaceful, retired kind of existence. Her husband, Count Alphonse, was extrovert and eccentric, the prisoner of the impulse of the moment. He enjoyed dressing up, and would make his appearance as a cowboy or a Circassian. On one occasion he sat down at the family lunch table wearing a Highlander's plaid and a dancer's tutu. His passions in life were hunting and hawking, and he was notoriously unfaithful to his wife. Their marriage soon ceased to be one in anything but name.

The Lautrec family had artistic impulses, but of a strictly amateur kind. Henri's father and uncles were competent draughtsmen. Count Alphonse did a little modelling too, making statuettes of horses and hounds. It is unlikely that Lautrec himself would have become a professional artist but for the cruelty of nature. He had always been a frail child, and in May 1878 he had a serious accident, fracturing his left femur. He had already been studying in the studio of the well-known

Fig. 1
Self-portrait
c.1890. Drawing,
14.5 x 12 cm.
Private collection

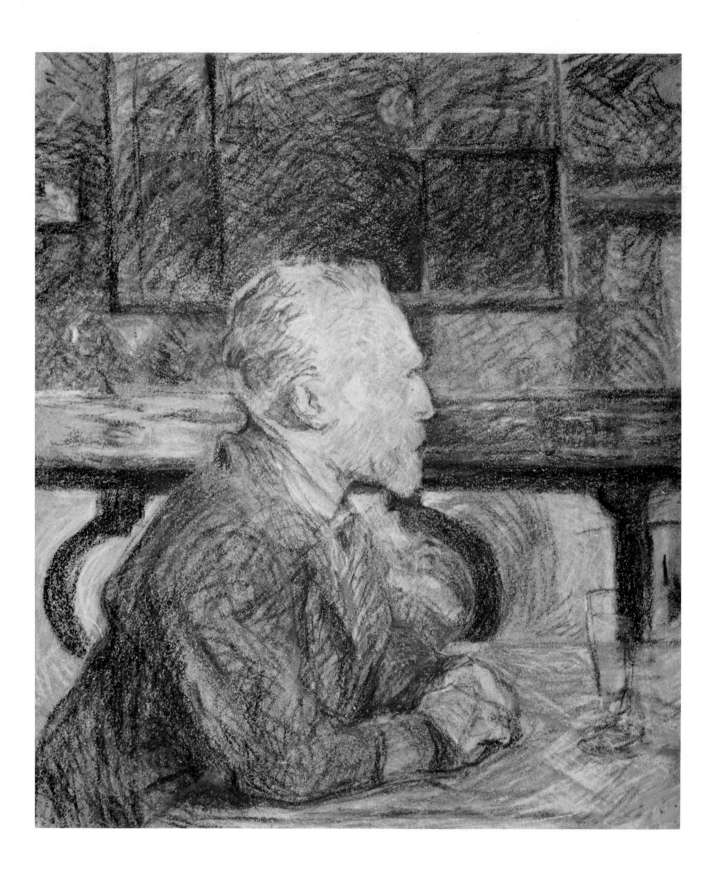

sporting artist René Princeteau, who was a friend of his father, and he spent his convalescence drawing and painting. But the bone was slow to mend. Fifteen months after the accident he was at last well enough to take strolls in the countryside accompanied by his mother. Then in August 1879 he had another accident, this time breaking his other leg. After these two fractures, Lautrec's legs stopped growing, although his torso matured normally. As his adolescence progressed he became a grotesque dwarf, with a thick nose, swollen, puffy lips, a retreating chin and a strange waddling walk (Figs. 1 and 7). It was clear that he would never become a vigorous sportsman like his father and grandfather.

Lautrec had been becoming more and more absorbed in his artistic activities, and now Princeteau helped him persuade his family (who were not wholly in love with the thought) that he should train as a professional painter. In March 1882 he entered the studio of Léon Bonnat, a well-known academic portraitist who was also celebrated for his prowess as a teacher. Here he gained a thorough grounding in those techniques of painting and draughtsmanship which had descended to Bonnat from David and Ingres, the two great neo-classical masters of the beginning of the century. It was upon their methods that all artistic instruction was still based. Despite his odd appearance Lautrec soon became popular with his fellow students, who loved him for his cheerfulness and appreciated the fact that he was free with his money. He discovered the pleasures of the Parisian cafés and café-concerts, and with them the pleasure of drinking. When Bonnat decided to close his studio, Lautrec, now thoroughly established as a boon companion, moved with the rest of his pupils to the atelier of another well-known academician, Fernand Cormon. This was situated at 10 rue Constance, Montmartre.

The Montmartre of the early 1880s, when Lautrec first knew it, was just beginning to enter into its period of greatest glory. The first cabarets had opened, there was a rustic dance-hall called the Moulin de la Galette, and there was the Chat Noir, a rendezvous for artists run by a man named Rodolphe Salis. Lautrec, who had been living with his mother in another district of Paris, now decided to share an apartment with a friend in Montmartre itself. This made all its night-time pleasures accessible to him.

Inevitably the Chat Noir was one of the places he frequented. But he found Salis pretentious, and came to prefer the Elysée-Montmartre, a nearby dance-hall which had become famous for its revival of the *chahut* (which we call the can-can) under the coy title of 'the naturalist quadrille'. Lautrec was immensely attracted by the frenetic energy of the dancers, and he found an equal attraction in the types who frequented the place. When Salis sold the Chat Noir, and it was re-opened by the singer Aristide Bruant (Fig. 26, Plate 29) as the Mirliton, he started to discover a renewed attraction there as well. He admired Bruant's sarcastic humour, his ability to express the miseries as well as the joys of those who lived on the fringes of society, and the rough way in which he treated prosperous customers come in search of a little low-life. Gradually, he started to abandon the subjects prescribed by convention, and to depict instead what really interested him.

His fascination for the stage probably derived from his own peculiarly alienated circumstances. The notion of disguise appealed to him – he loved dressing up almost as much as his father did, and a number of strange photographs (some showing the painter in female costume) survive to prove it. The effects produced on stage – by dress and lighting – were part of the whole process of alienation, which removed

Fig. 2
Portrait of Van Gogh
1887. Pastel on cardboard,
54 x 45 cm.
National Museum Vincent
Van Gogh, Amsterdam

the performer into another sphere, and enabled him or her to find an intensity otherwise unavailable.

As his interest in the cabaret and theatre developed, a number of other important events had taken place. Lautrec had encountered the young painter Emile Bernard (Plate 2), a fellow-student in Cormon's studio, and had imbibed from him ideas which came from the Impressionists. A little later, once again *chez* Cormon, he met Vincent van Gogh (Fig. 2). Bruant, with whom he had become friendly, hung some of his pictures at the Mirliton, and asked him, in addition, to do some designs for a magazine he was producing. Other signs of recognition followed. In 1888, Lautrec was asked to exhibit with 'Les Vingt' in Brussels – a great honour since it was probably the most advanced exhibition-society in Europe. This was also the year, according to leading authorities, in which he contracted syphilis from a girl called Rosa la Rouge (throughout his life he was to be attracted to red hair).

By the end of the 1880s, Lautrec's pattern of living was set, and it was to continue with minor variations until his death. Despite his small stature, he was a man of enormous energy, who could make do with very little sleep. He spent his time rambling from night-time entertainment to night-time entertainment, surrounded by a little court whose most conspicuously faithful member was his cousin, Dr Gabriel Tapié de Céleyran (Figs. 3 and 21, Plate 22). Despite his appearance, Lautrec was not without the consolation of female company. His sexual energy, too, was immense. He described himself jokingly as 'a coffee-pot with a large spout'. But the girls he went with were never those of his own class, and rarely was there any pretence of love. One of the few for whom he seems to have felt real affection was Suzanne Valadon (Fig. 11, Plate 3), well-known as a model, and in secret a painter herself. The affair, marked from the outset by violent quarrels, broke up when Lautrec began to think that Suzanne was exploiting him on the instructions of her mother.

The painter not only lived hard; he ate and drank enormously. By the middle of the 1890s, he was an alcoholic, and by 1898 chronic alcoholism was taking its toll of his art. In February 1899 he had an attack of delirium tremens, and had to be taken to an asylum in Neuilly. He stayed there until May, and got his release partly thanks to the amount of work he produced in an effort to prove his sanity. But he soon started drinking again. In August 1901, while on holiday in the country, he was struck down by a paralytic stroke, connected either with his alcoholism or with the syphilis from which he had long suffered. Three weeks later he died at his mother's house.

There is, within the relatively brief span of his activity as an artist, a discernible pattern of development in Lautrec's work. It can be traced in two ways. First, through a gradual change in subject-matter. Secondly, through changes in technique. Lautrec began as a painter of dance-halls and cabarets; a poster done for the Moulin Rouge in 1891 (it had opened its doors in the autumn of 1889) marked the beginning of his reputation with his contemporaries. Even today, people tend to associate him with dance-hall scenes, perhaps because the paintings, prints and posters dealing with this theme are the liveliest things he ever produced, and are connected with the image of 'gay Paree' with which Lautrec has been vulgarly associated. Yet he was already losing interest in Montmartre as early as 1892, and when he reverted to painting the Moulin Rouge in the middle of the decade, it was partly as a favour to La Goulue, who wanted some panels for a booth she had opened at the Foire du Trône. This was the kind of commission that was bound to tickle Lautrec's fancy. He produced what she wanted,

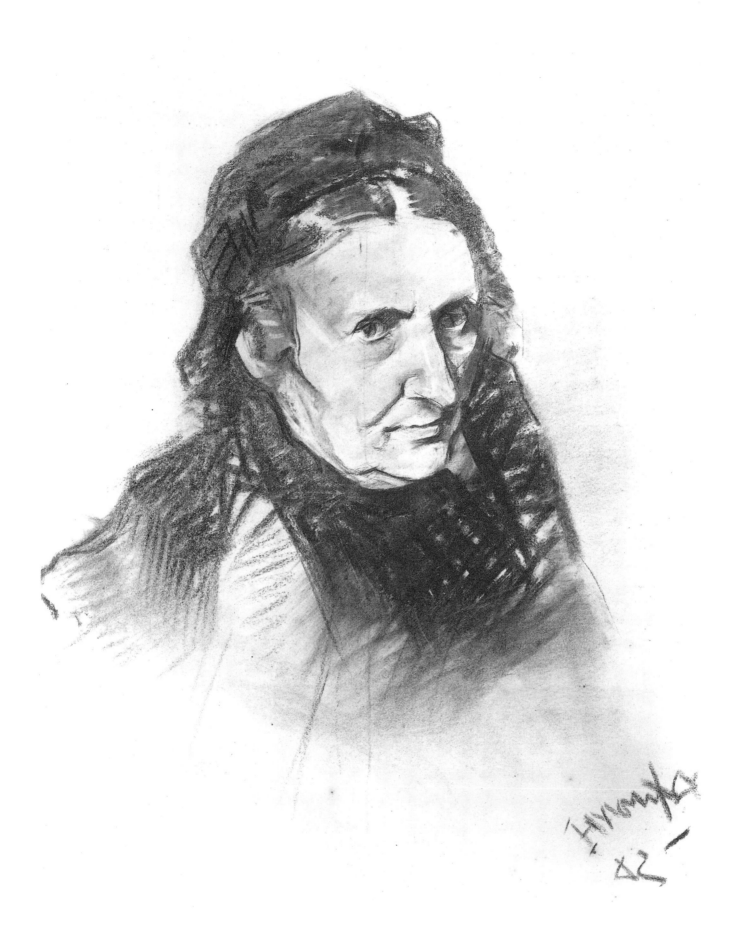

and mischievously included a portrait of Oscar Wilde, whom he had recently met while on a visit to England, among the spectators (Plate 30).

From his fascination with Montmartre Lautrec progressed in two directions. The stars of the café-concerts now took the place of the virtuoso cancan dancers at the centre of his private pantheon. Chief among them was Yvette Guilbert (Figs. 16 and 17, Plate 18). He also began to take an interest in theatre scenes in general as material for pictures. The other direction led towards the licensed brothels. Lautrec became obsessed with the secret life behind their closed doors, and began to paint and draw the girls in their off-duty moments (Figs. 11, 22, 23, Plates 25, 26, 27, 44). In 1894 he went so far as to take up residence in a newly opened and very splendid brothel in the Rue des Moulins, and used the main reception room as the subject for one of his most ambitious compositions (Plate 24). One facet of life in these establishments was the way the girls, starved of real affection by the very nature of their profession, turned for consolation to one another. Lesbian love-affairs were commonplace in the *maisons closes*, and these, too, Lautrec depicted – for example in *Les Deux Amies* (Fig. 23, Plate 26). An interest in Lesbian behaviour as he saw it in the brothels led him, towards the end of his career, to frequent some of the best-known lesbian bars, and he did paintings and drawings inspired by what he had seen there.

This by no means exhausts the range of the subjects Lautrec chose to tackle, though it always remained fairly restricted. In 1895, he had a brief passion for the newly fashionable sport of bicycling, and attended the bicycle races at the Vélodrome Buffalo, which was managed by the writer Tristan Bernard. He did circus scenes – nearly forty of them when he was in the asylum at Neuilly – and there are portraits of friends, of his immediate family (Figs. 3 and 4) and a few pictures connected with racing and yachting. One thing which didn't interest him at all was landscape, though there are a few landscape sketches dating from the early 1880s when he had not yet found his true path.

Lautrec's interest in the stage naturally affected his technique. He was particularly fascinated by stage lighting, which in his day remained crude, and was adept at rendering its harsh effects (Fig. 5, Plates 16 and 20). He was especially interested by the way in which the footlights (many café-concerts, in particular, had stages lit by footlights only) revealed whole new systems of protuberances and hollows in the faces of the performers.

Lautrec's technical progress was marked by the absorption of a number of outside influences, and also by a process of experiment and discovery which lasted until the middle 1890s, and which only began to flag as alcoholism increased its grip on him. He was, in particular, influenced by Japanese prints, which were then becoming fashionable in Europe. Lautrec saw a large exhibition of these at the Galerie Georges Petit in the spring of 1883, and immediately started to make a collection. He even spoke of going to Japan. His mother approved of the project, and offered to give him the fare. Lautrec declined, because he thought he had not as yet learned everything he could in Cormon's studio. In 1896 he was still toying with the idea of making the trip.

The attraction of Japanese art, so far as Lautrec was concerned, was precisely the same as its lure for some of the most gifted of his contemporaries, among them Degas and Van Gogh. From the *ukiyo-e* printmakers he learned not only how to use flat colour areas, bounded by a definite outline, but how to choose a point of view that enabled him to express a personal vision of the subject. The great Japanese

Fig. 4
Portrait of Count
Charles de Toulouse-
Lautrec
(the artist's uncle)
1882. Charcoal on paper,
61 x 47 cm.
Private collection

printmakers, such as Utamaro, picked their angle to intensify the spectator's experience of what was being shown. Lautrec followed their example. Figures and objects that loomed large in the foreground of the composition might, so he discovered, play only a subsidiary part in the meaning of the whole, yet might nevertheless direct the attention to precisely the right spot. Similarly, he learned from the Japanese how the visible detail or fragment may be used to conjure up an unseen whole. Yvette Guilbert's famous shoulder-length gloves took the place of the singer herself (Figs. 16 and 17, Plate 18).

Lautrec was on the whole less slavishly dependent on Japanese printmakers than some of his contemporaries. He never produced actual paraphrases of Japanese art as Van Gogh did. But in spirit he was closest of all to *ukiyo-e* artists. Like them, he was interested in the stage, and his paintings and lithographs showing performers are exactly equivalent to the actor prints that formed so large a part of their output. He sought intensity in actors or singers at work; so did Sharaku, the greatest maker of Japanese actor-prints. Lautrec's fascination with life in the Parisian *maisons closes* similarly runs parallel to Utamaro's depictions of the activities of the geishas and their attendants.

But Lautrec did not learn from the Japanese alone. He felt the impact of his contemporaries. Among artists senior to him, the one he admired most was Degas, from whom he took the determination to search for a truthful vision of ordinary life. It was Degas who directed him in his explorations of the world of the theatre and the circus. And Degas was interested, long before Lautrec, in new methods of composition suggested not merely by Japanese prints, but by photography. Lautrec was always hoping for a word of praise from Degas. When it

Fig. 5
Cécy Loftus
1894. Lithograph,
37 x 24.5 cm.

Fig. 6
Horse and Carriage
1884. Pencil, 15 x 25.5 cm.
Wilmer Hoffman Bequest,
The Baltimore Museum
of Art

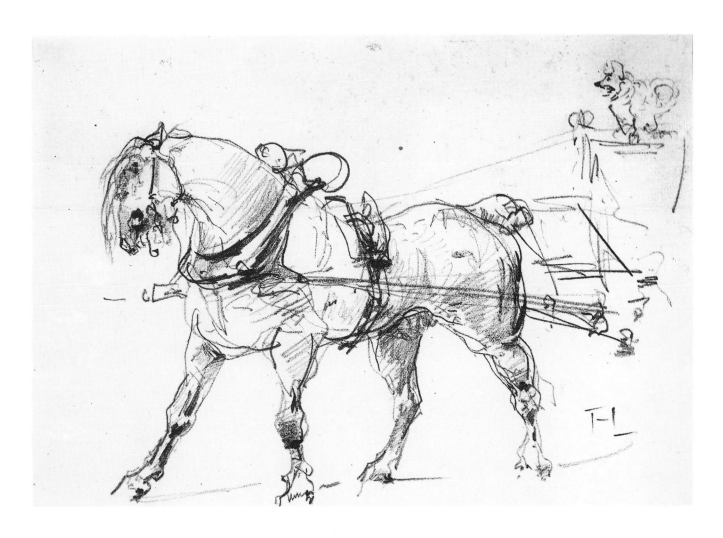

Fig. 7
Caricature, self-
portrait
c.1890. Black chalk,
25.5 x 16 cm.
Museum Boymans-Van
Beuningen, Rotterdam

Fig. 8
The Doctor's Visit
(a caricature of the
artist's cousin, Gabriel
Tapié de Céleyran)
1893. Drawing, 26 x 18 cm.
Cabinet des Dessins,
Musée du Louvre, Paris

came, however, it was ambiguous. Degas, seeing a work by Lautrec hanging in the apartment of mutual friends, remarked: 'To think a young man has done this, when we have worked so hard all our lives!'

Jean-Louis Forain is another and lesser artist from whom Lautrec learned something. He had been aware of Forain's talent from an early age, since Forain was a friend of his father, Count Alphonse. What Lautrec took from him was an awareness of the virtues of draughtsmanship that verged on caricature. Through Aristide Bruant, who hung some examples on the walls of the Mirliton, he also knew the work of Alexandre Steinlen, another artist with a caricaturist's gift for catching the essence of Parisian scenes. These two lesser painters inspired and guided him when he was given commissions for poster-designs; they led him towards the kind of bold simplification that would make a poster 'tell' to the uttermost, no matter where it was placed. His poster work encouraged him to make simplifications also in his paintings.

One other influence should be mentioned here: that of Lautrec's friend Van Gogh, whose system of bold cross-hatching in paint undoubtedly contributed something to Lautrec's methods. Lautrec was not merely an outstandingly able draughtsman; the bones of his draughtsmanship were more clearly visible in everything he did as a mature artist than was common with his contemporaries. The energy to be found in his canvases, despite their bright and simple hues, was not the energy of colour so much as the energy of line. This savage linear energy was indeed one of the things that most clearly separated him from others.

A discussion of Lautrec's influences leads directly to a discussion of his place in the general history of late nineteenth-century painting. The strangeness of his physical appearance was to some extent matched, despite his ability to learn from his contemporaries, by the isolation of his art. The only artist with an even remotely similar viewpoint was Degas, and no doubt this was the reason Lautrec worshiped him. Like Degas, Lautrec seems to have regarded human beings as animals, creatures without any spiritual dimension worth considering. This attitude had its roots in his physical deformity, and was confirmed by his initial training in the atelier of an animal painter. Of all artists, sporting painters have the greatest detachment from their subject-matter. They aim to tell a scientific kind of truth, and their patrons are more interested in truth of this sort than they are in artistic content. This applies to Princeteau's own work and still more to that of the better-known John Lewis Brown, whom Princeteau taught Lautrec to admire and emulate.

Lautrec's early drawings (Fig. 6) show the clear impact of these sporting artists. Another important early influence was the caricatures which the young artist saw in the popular press. He was to be a skillful and amusing caricaturist throughout his career, as unsparing to himself as he was to others (Figs. 7 and 8). Here we find the satirist's ability to stand aside from events and offer a concise judgement on what he sees.

There is, however, a difference between the objectivity of Degas's subjects and that of Lautrec's (Fig. 9). Degas was intensely interested in the commonplace. More and more he came to paint people (nearly always women) engaged in their daily tasks – ironing, washing themselves (Fig. 30, Plate 37) – and quite unconscious of the presence of a spectator. Even when Degas painted dancers, he was showing what to him was a form of work. (His ballerinas are notoriously ungraceful, and are sometimes quoted by dance-historians to demonstrate the depths to which the ballet had fallen in France before the arrival of Diaghilev and his Ballets Russes.)

Fig. 9
Miss Ida Heath
1896. Lithograph,
36 x 26.5 cm

Lautrec did occasionally paint people who were introspectively sunk into themselves, but more often he was interested in the reverse: the quality the performer possesses when he or she is projecting emotions and ideas, above all personality, to an audience in the most forceful possible way. His portraits of Yvette Guilbert are obvious examples (Figs. 16 and 17, Plate 18). Lautrec was also interested in the way the performer's mood can be reflected in those who are watching or listening. Finally, he noted the way in which the star performer unconsciously radiates her attraction even before she has begun to perform, or after the performance is over.

Lautrec's legend has him keeping company with nothing but can-can dancers, models and tarts. Of course this was far from being the case. Some of the performers he most admired were people of taste, intelligence and sensibility. Besides, he did not in any case live entirely in the world of the brothel, the dance-hall and the theatre, and he never severed his links either with his family or with the world of well-bred, cultivated people.

One salon he frequented was that of the beautiful Misia Natanson, a young Polish girl who was then married to Thadée Natanson, the founder, with his brother Alexandre, of the Symbolist periodical *La Revue Blanche*. Among the others who came to the same house were the poets Mallarmé and Valéry, the art-critic Félix Fénéon (Plates 33 and 34), the writers Colette, Jules Renard and Henri de Régnier, the composer Debussy, and the painters Vuillard and Bonnard. In fact, almost every artistic personality worth meeting in the Paris of the time was there at one time or another.

Young as she was – or perhaps it was because she was so young – Misia was an accomplished breaker of hearts. Lautrec often stayed with her at her country house, as well as visiting her in town, and in a book of memoirs written in old age she gives a charming account of how they sometimes spent their time together: 'I would sit on the grass, leaning against a tree, engrossed in some entrancing book; he would squat beside me, and, armed with a paintbrush, dexterously tickle the soles of my feet. This entertainment, in which his finger sometimes played a part at propitious moments, sometimes lasted for hours. I was in the seventh heaven when he pretended to be painting imaginary landscapes on my feet.'

Lautrec's connection with the *Revue Blanche* gives us a guideline when we come to consider his artistic orientation. His fellow-student Emile Bernard had gone on to become one of the founders of the group who called themselves the Nabis (Nabi being the Hebrew word for prophet). It was he, indeed, who had been responsible for erecting some of Gauguin's ideas into a systematic doctrine, and he and his associates had become one of the many sects into which the Symbolist movement was divided. Bonnard and Vuillard, Misia's court painters, also belonged to the group. Bonnard in particular makes an interesting comparison with Lautrec, not least because their histories touch at several points other than this. They both designed posters for the Natansons' magazine (Lautrec's featured a portrait of Misia herself (Fig. 10), and they had already exhibited together as early as 1891. In 1893 they made a joint appearance in a print portfolio put out by *L'estampe originale*. This contained work by a large number of Symbolist artists – Bernard, Eugène Carrière, Maurice Denis, Puvis de Chavannes and Odilon Redon. Gauguin was also included. Like Lautrec, Bonnard was a pioneer in poster design, and there is even some argument as to whether or not certain innovations should be credited to him rather than to his contemporary and rival. But the

resemblances go deeper than this. Because Lautrec's brothel scenes are in the conventional sense sordid, we tend to forget that they are as intimate as Bonnard's interiors. Lautrec's obsession with women is echoed in Bonnard's long series of paintings showing women washing themselves, which are far more erotic than similar scenes by Degas. Indeed, the more closely one studies the work of these two painters, the more convinced one becomes that they took a similar view of art and its possibilities.

Lautrec is now generally put forward by his admirers as an unsparing realist. A present-day art historian compares him both to Caravaggio and to Courbet and asserts that his achievement was 'to release painting from all its current taboos'. He continues: 'The extraordinary thing about Lautrec, or rather the thing that made him seem extraordinary to the public of his day, was that he alone, among all the painters of that period, set down exactly what he saw, without evasions, without comment and without distortion. In contrast to the erotic, suggestive art of the eighteenth- and nineteenth-century *petits maîtres*, . . . Lautrec shows life as he saw and experienced it.'

This view is utterly inadequate. In the first place, the opening sentence is simply wrong: Degas made monotypes of brothel scenes, and Courbet painted pictures showing lesbian activities; both artists were as objective as anyone could wish. Secondly, the judgement is grossly oversimplified. An attempt to analyse Lautrec's art must proceed towards a single centre from several different directions at once. One of these is purely personal. Lautrec was so grossly crippled physically that his disabilities necessarily reflected themselves in his painting. He was a man of immense courage, and he did not react by becoming bitter. The view he took of women was considerably less harsh than that of the misogynous Degas. For Lautrec it was personality that counted: he relished the greedy energy of *La Goulue* (Fig. 12), the wit of Yvette Guilbert, the babyish perversity of May Belfort, but without trying to make any distinction between these qualities. The reason why he stopped short was clearly sexual. Cursed with a huge sexual appetite, he saw himself as someone for ever debarred from forming any kind of personal relationship. He thus saw women with sympathy, but also with an almost total detachment, rooted in a refusal (perhaps less admirable than it seems at first) to construct moral hierarchies or to say that one mode of behaviour was preferable to another. The only thing that ruffled the surface of this detachment was voyeurism. Lesbians played so prominent a role in his painting not only because he happened to come in contact with them, but because they have commonly fascinated men who have doubts about their own sexual adequacy.

As for the artistic ethos of the time, it is usual to place Lautrec in the naturalist tradition, and to see him as the heir of Courbet, though admitting at the same time (because the fact is so obvious) that his pictures are devoid of social indignation. To say that they are devoid of comment is another matter. Lautrec was born an aristocrat and remained one, even in small matters such as the tyranny he exercised over his drinking companions and friends. One of the things most frequently misunderstood about him is the aristocratic tendency of his art. Like his father, Lautrec was indifferent to public opinion. And, once again like his father, he felt that it was quite all right to pursue a course of action – such as taking up residence in a brothel – which would have seemed disgraceful in others. But he never courted scandal in the manner of a bourgeois painter in rebellion against his own background. When he exhibited *Elles*, the series of lithographs which show

Fig. 10
Misia Natanson
Skating (Study for
the poster 'La Revue
Blanche')
1895. Pencil and oil on
paper, 148 x 105 cm.
Musée Toulouse-Lautrec,
Albi

the life of the brothel and its inhabitants, he was careful to do so in such a way that they were available only to those who would not be shocked by them (Fig. 34, Plate 44).

As we have already seen, Lautrec maintained links of friendship with many members of the Symbolist generation to which he himself belonged. When he exhibited his paintings or published his prints they tended to appear in a recognisably Symbolist context. For example, the Brussels 'Vingt', which so consistently supported him, was a great force in the dissemination of Symbolism. These are not accidental conjunctions. It is conventional wisdom to see the Symbolist painters as the purveyors of an extraordinary dream-world, in total contrast to the photographic naturalism of the Salon. The position of the Impressionists, exponents of a naturalism that was not academic, is left unresolved between these two divergent currents. The difficulty which arises here is the general ignorance which now prevails concerning what the Salons actually contained.

They did show large numbers of pompous portraits (as painted by Bonnat), of historical costume pieces (as painted by Cormon), and of the flimsily draped nudes that satisfied the covert erotic feelings of bourgeois visitors, but they also contained much that fell into none of these categories. The numerous depictions of contemporary life produced annually by highly competent academic artists covered the whole of the social spectrum. There is in fact some evidence that in French official exhibitions the pictures on working-class themes somewhat outnumbered those that showed the cosseted existence of the more prosperous. Nor were these pictures, as one might expect, heavily humorous or else sentimental. They took a notably clear-eyed view of the urban proletariat, as well as of the rural labouring class that formed a more traditional subject for picture-making. These artists were the heirs of mid-century naturalism, and the true successors of Courbet. It was their painting, too, that, while often eschewing overt comment on what it showed, made reference to a moral centre.

Lautrec's typical subject-matter was not the working class as such, but those who live on the margin of society. His dancers, as much as his whores, were marginal people, picking up an untypical living. People of this kind had certainly found a place within the naturalist spectrum. We find them well represented in the great panorama of Zola's fiction. But it is not Zola who prompts a comparison with Lautrec – it is Maupassant. The inhabitants of Maupassant's *Maison Tellier* are recognisably the same as the girls who appear in Lautrec's brothel-scenes. Maupassant's transparent prose, the ironic detachment with which he manipulates his plots, alike remind us of the qualities we find in a painting such as the famous *Salon in the Rue des Moulins* (Plate 24). And this is significant because there is some dispute about Maupassant's precise relationship to the naturalist movement in literature.

In any case, it is an error to suppose that recognisably Symbolist writers avoided the realistic. Huysmans, when he abandoned his earlier style (which had been an imitation of Zola) to write *Là-Bas* and *A Rebours*, did indeed seem to step from one realm to another, though the distance he moved was no greater than that between Flaubert's *Madame Bovary* and the same writer's *Tentation de Saint Antoine* and *Salammbô*. But it is Flaubert who has the better claim to be one of the tap-roots of Symbolism, and Flaubert never abandoned interest in everyday reality. One branch of Symbolist literature concerned itself with intensely realistic, sordid and wilfully 'shocking' material – Verlaine's erotic poems are a case in point. The difference was that these works were no longer constructed around a moral armature of the old kind. The rarefied world of Symbolic vision was balanced against,

and indeed compensated for, the interest in decadence. At their most hectic the decadents thought of themselves as being the victims of an irremediable sickness in society, and it was they who made a cult-figure of the prostitute, perhaps originally taking their cue from Baudelaire and certain poems in the *Fleurs du Mal*.

It can, of course, be argued that there is a great difference between Lautrec's robust version of low life and the kind of thing that openly decadent artists and poets made of it. This is quite true. What is not taken into account by this argument is one very significant aspect of Lautrec's approach to his material. Robust and incisive he may be, but he constantly manipulates, by means of devices taken from Degas and the Japanese, the spectator's attitude towards it. It is astonishing how seldom he allows us to look at anything from quite the expected point of view, at least in the physical sense. Unlike Caravaggio, to whom he has been compared, he is concerned not to make us feel that we are in the presence of the scene itself, but that we are the witnesses of an act of transformation, the sea-change of life into art. This implies a typically Symbolist attitude towards what he painted.

This view is not invalidated, indeed it is strengthened, by a peculiarity of Lautrec's work. His sources and influences, as well as his subject-matter, are largely popular ones. His family background had led him to begin his career with a man who produced sporting pictures; this made an indelible mark. Sporting pictures, even raised to the plane to which Stubbs brought them in England, have the quality of being half-way between high art and popular or folk painting – which may be the reason that they have reached such heights of favour with mid-twentieth-century collectors. To the initial influence of Princeteau, Lautrec added those of Japanese prints and of the contemporary posters he saw in the streets. The first were certainly meant to reach a large public – they were originally sold for a few coppers in the streets of Edo. The second were popular by their very nature. Lautrec learned valuable lessons from designing posters, lessons that he proceeded to apply elsewhere, but his decision to undertake them at all was the really significant thing. By doing so, he was expressing an attitude towards the role of the artist. It was not incompatible with his essentially aristocratic attitude towards the image itself to wish to democratise it once it had been created. The urge towards the democratisation of art was felt particularly strongly among Symbolists, for it was they who had become dissatisfied with the official Salons as a means of disseminating both works of art and artistic ideas. A division could be made, and often was, between the notion of 'art for art's sake' and what happened to the artist's product once it had come into existence. In Belgium, where Lautrec met so much appreciation, many of the leading Symbolists were also socialists, thus following in the footsteps of William Morris.

A better way of estimating Lautrec's achievement is to look not at its origins but at its parallels and consequences. An infrequently cited but very relevant parallel is provided by the work of the Norwegian Expressionist Edvard Munch, who came to Paris as a student in 1885, when Lautrec was just coming to the end of his own apprenticeship. Munch came again in 1889, and studied under Bonnat, just as Lautrec himself had done, then travelled back and forth between Norway and Paris until 1892, when he removed himself to Berlin. There is no evidence that he and Lautrec met, but Munch could certainly have seen Lautrec's poster for the Moulin Rouge as it went up in the streets in 1891. Though Munch's most powerful compositions, many produced during the 1890s, are openly and deliberately symbolic, and

have none of Lautrec's tendency to stand aside from the emotions, they do, in details of colour and handling, have a distinct resemblance to what the Frenchman was doing at the same moment. The cousin-hood between Lautrec's big Moulin Rouge compositions and Munch's *Dance of life* of 1899-1900 is very obvious. When one looks at Munch's paintings one often seems to see Lautrec's techniques taken a stage further in boldness and stylisation, and that raises the possibility that Lautrec's apparent impassivity is trembling on the brink of turning into its opposite – that the mask of one of his performers might crack open into the anguished scream that Munch depicted.

When one speaks of the 'consequences' of Lautrec's work, one can look in one direction only – at his impact on the young Picasso. Picasso arrived in Paris for the first time about a year before Lautrec's death. The artistic ambience he came from, in Barcelona, was distinctly Symbolist, and Picasso was to remain a belated Symbolist right down to the middle of the first decade of the new century. But it was Lautrec whom he chose to follow when he first arrived in France, and there exists within his enormous oeuvre a small group of early paintings in Lautrec's manner, dating from around 1901. They are inferior to Lautrec's because they lack the keenness and directness of observation that Lautrec invariably put into his work. Picasso's courtesans are types, not individuals. Yet it is perfectly possible to argue that it is Lautrec's acrid harshness, as well as the lessons learned from Negro art, which comes to the surface again in the great *Demoiselles d'Avignon* of 1907, which, more than any other work, is the definitive announcement of the birth of the Modern Movement. Lautrec's aristocratic sense of separateness, which was purely personal, is here transformed into a gesture of defiance directed against all previously held assumptions about the nature of painting.

The paradox is that the aristocrat is the one who democratises art, by arrogantly removing from it any pretence to moral instruction. The art of the 19th century, from David onwards, was deeply involved in a debate about moral ideas. David's *Death of Morat* foreshadows the whole course of nineteenth-century painting, until the appearance of the Impressionists, and after them of Lautrec. But his effect is more drastic, because he is both amoral and urban. He shows us not nature, but man, and man as a social being. And, in effect, he then declares that human relationships are fundamentally meaningless.

It can even be said that Lautrec brought painting to a position which foreshadows the basic problem of the Modern Movement. How is the artist to remain true to the demands of his art, and yet fulfil the role of teacher which the nineteenth century still imposes on him? Lautrec's refusal to instruct, his aloofness from ideas about morality, make him a seminal figure in the history of nineteenth-century painting.

To try to restore Lautrec to his true position within Symbolism is in no sense to denigrate his achievement as an artist. Rather, it is an attempt to show why his work has retained its force. The mere fact that an artist chose to paint brothel scenes, and to give an unvarnished view of the way prostitutes behaved when they were alone together, might have been enough to shock the public of Lautrec's own time. We must beware of saying that it *did* shock them, since, despite occasional denunciations, Lautrec's career was free of the kind of major scandal that his subject-matter would certainly have aroused in England or in the United States. Today, however, his power to shock in this fashion is much attenuated; and even the raunchy dance-halls and cabarets he painted are preserved only in sentimental folk-lore. Anything of them that remains alive is so because Lautrec chose to paint it.

The gallery of individuals he created is memorable because each of these individuals is projected so passionately by the paradox of the artist's own emotional reticence. His inner numbness set him free to look for the most expressive methods of rendering what he had seen. Conventional methods of constructing a head or a body could be sacrificed to the need to achieve maximum impact because ordinary humanity itself seemed remote. It is not his own feelings that the artist is trying to articulate; and the distortions he uses are not the product of the pressure of his own emotions (as they might be in Munch) but are imposed from outside, and spring from the inner urgency of the subjects themselves. The ultimate way in which his aristocracy of spirit showed itself was in his assumption that he could absorb any expression of individuality, however violent, into the larger individuality of his art.

Outline Biography

1864 Born 24 November.

1872 Begins his schooling at the Lycée Fontanes (now Condorcet) in Paris. Starts to frequent René Princeteau's studio.

1878-79 Fractures his legs.

1882 Enters Bonnat's studio.

1883 Begins to work in Cormon's studio.

1884 Meets Emile Bernard.

1885 Meets Aristide Bruant and Suzanne Valadon, who becomes his mistress. Begins to frequent the Montmartre cabarets and dance-halls.

1886 Meets Van Gogh. Leaves Cormon's studio. Exhibits at the Mirliton.

1888 Exhibits with 'Les Vingt' in Brussels. Quarrels with Suzanne Valadon. Contracts syphilis.

1889 Exhibits for the first time at the Salon des Indépendants.

1890 Visits Brussels.

1891 Produces a poster for the Moulin Rouge.

1892 Makes his first lithographs.

1893 Becomes acquainted with the *Revue Blanche* circle. Begins to paint theatrical subjects.

1894 Again visits Brussels. Takes up residence in the brothel in the Rue des Moulins.

1895 Designs posters for May Belfort, May Milton, and the *Revue Blanche*. Paints panels for La Goulue's booth. Visits London and meets Oscar Wilde.

1896 Begins to visit lesbian bars. Publishes *Elles*, prints depicting prostitutes.

1898 Exhibits at the Goupil Gallery, London. Illustrates Jules Renard's *Histoires Naturelles*. His health begins to deteriorate.

1899 Taken to an asylum at Neuilly after an attack of delirium tremens. Stays there until May, and is released into the care of a guardian. Starts drinking again on his return to Paris in the autumn.

1900 Visits Le Havre, Arcachon and his mother's country house at Malromé in the Bordelais.

1901 Returns to Paris and does some painting. In August, at Taussat, has a paralytic attack. Is taken to Malromé, where he dies on 9 September.

Select Bibliography

Adhémar, Jean. *Toulouse-Lautrec – Complete Lithographs and Drypoints*. London, 1965.

Bouret, Jean. *Toulouse-Lautrec*. London and New York, 1964.

Cooper, Douglas. *Toulouse-Lautrec*. London, 1955.

Dortu, M.G. *Toulouse-Lautrec et Son Oeuvre* (6 vols.). New York, 1971.

Julien, Edouard. *Les Affiches de Toulouse-Lautrec*. Paris, 1950.

Lassaigne, Jacques. *Lautrec*. Geneva, 1953.

Lucie-Smith, Edward. *Symbolist Art*. London and New York, 1972.

Mornand, Pierre. *Emile Bernard et Ses Amis*. Geneva, 1957.

Natanson, Thadée. *Un Henri de Toulouse-Lautrec*. Geneva, 1951.

Novotny, Fritz. *Toulouse-Lautrec*. London, 1969.

Perruchot, Henri. *Toulouse-Lautrec*. London, 1960.

Sert, Misia. *Two or Three Muses*. London, 1953.

Tietze, Hans. *Toulouse-Lautrec*. New York, 1953.

Toulouse-Lautrec, Henri de. *Elles*.

Toulouse-Lautrec, Henri de. *Unpublished Correspondence*. London, 1969.

List of Illustrations

Colour Plates

1. Artilleryman and Girl
c.1886. Oil on tracing paper, 56 x 45 cm.
Musée Toulouse-Lautrec, Albi

2. Emile Bernard
1885. Canvas, 54 x 44.5 cm.
The Tate Gallery, London

3. Suzanne Valadon
1886. Canvas, 54 x 45 cm.
The Ny Carlsberg Glyptotek, Copenhagen

4. Jeanne Wenz
1886. Canvas, 81 x 59 cm.
The Art Institute of Chicago

5. Emile Davoust
1889. Cardboard, 45 x 35 cm. Kunsthaus, Zürich

6. Gabrielle
1891. Cardboard, 67 x 53 cm.
The National Gallery, London

7. Justine Dieuhl
c.1891. Cardboard, 74 x 58 cm. Musée d'Orsay, Paris

8. 'A la Mie'
1891. Cardboard, 53 x 68 cm.
Museum of Fine Arts, Boston

9. Moulin Rouge – La Goulue
1891. Poster (coloured lithograph), 194 x 122 cm.

10. Woman with a Black Feather Boa
c.1892. Cardboard, 53 x 41 cm. Musée d'Orsay, Paris

11. Woman with Gloves (Honorine P.)
c.1890. Cardboard, 54 x 40 cm. Musée d'Orsay, Paris

12. At the Moulin Rouge:
Two Women Dancing
1892. Cardboard, 93 x 80 cm.
National Gallery, Prague

13. Reine de Joie
1892. Poster (coloured lithograph), 136 x 91 cm.

14. Head of the Englishman at the Moulin
Rouge
1892. Cardboard, 57 x 45 cm.
Musée Toulouse-Lautrec, Albi

15. The Englishman at the Moulin Rouge
1892. Lithograph, 47 x 37 cm.

16. At the Moulin Rouge
1892. Canvas, 123 x 140.5 cm.
The Art Institute of Chicago

17. Jane Avril in the Entrance of the Moulin
Rouge
1892. Oil and pastel on cardboard, 102 x 55 cm.
Courtauld Institute Galleries, London

18. Yvette Guilbert Taking a Curtain Call
1893. Watercolour, 42 x 23 cm.
Rhode Island School of Design, Providence

19. Divan Japonais
1893. Poster (coloured lithograph), 79.5 x 59.5 cm.

20. M. Praince
1893. Cardboard, 51 x 36 cm. Private collection

21. Confetti
1894. Poster (coloured lithograph), 54.4 x 39 cm.

22. Dr Gabriel Tapié de Céleyran
1894. Canvas, 110 x 56 cm.
Musée Toulouse-Lautrec, Albi

23. Dance at the Moulin Rouge
1890. Canvas, 115 x 150 cm.
Collection Henry P. McIlhenny, Philadelphia

24. The Salon in the Rue des Moulins
1894. Pastel, 111.5 x 132.5 cm.
Musée Toulouse-Lautrec, Albi

25. The Card-players
1893. Cardboard, 57 x 44 cm.
Hahnloser collection, Berne

26. Les Deux Amies
c.1894. Cardboard, 48 x 34 cm.
The Tate Gallery, London

27. Woman Adjusting her Garter
1894. Cardboard, 58 x 46 cm. Musée d'Orsay, Paris

28. Loïe Fuller
1893. Poster (lithograph coloured by hand),
43 x 27 cm. Bibliothèque Nationale, Paris

29. Aristide Bruant
1893. Poster (coloured lithograph), 127 x 92.5 cm.

30. Oscar Wilde
1895. Watercolour, 58.5 x 48 cm. Private collection

Text Figures

1. Self-portrait
 c.1890. Drawing, 14.5 x 12 cm.
 Private collection

2. Portrait of Van Gogh
 1887. Pastel on cardboard, 54 x 45 cm.
 National Museum Vincent Van Gogh, Amsterdam

3. Portrait of Louise Tapié de Céleyran
 (the artist's grandmother)
 1882. Charcoal on paper, 62 x 47 cm.
 Private collection

4. Portrait of Count Charles de Toulouse-
 Lautrec (the artist's uncle)
 1882. Charcoal on paper, 61 x 47 cm.
 Private collection

5. Cécy Loftus
 1894. Lithograph, 37 x 24.5 cm.

6. Horse and Carriage
 c1884. Pencil, 15 x 25.5 cm. Wilmer Hoffman
 Bequest, The Baltimore Museum of Art

7. Caricature, self-portrait
 c.1890. Black chalk, 25.5 x 16 cm.
 Museum Boymans-Van Beuningen, Rotterdam

8. The Doctor's Visit (a caricature of the artist's
 cousin, Gabriel Tapié de Céleyran)
 1893. Drawing, 26 x 18 cm.
 Cabinet des Dessins, Musée du Louvre, Paris

9. Miss Ida Heath
 1896. Lithograph, 36 x 26.5 cm

10. Misia Natanson Skating
 (Study for the poster 'La Revue Blanche')
 1895. Pencil and oil on paper, 148 x 105 cm.
 Musée Toulouse-Lautrec, Albi

Comparative Figures

11. The Morning After
 1889. India ink and blue chalk, 48 x 63 cm.
 Musée Toulouse-Lautrec, Albi

12. La Goulue Waltzing with Valentin-le-
 Désossé
 1894. Lithograph, 30 x 23 cm.

13. Study for the Poster 'Reine de Joie'
 1892. Charcoal, 152 x 105 cm.
 Musée Toulouse-Lautrec, Albi

14. La Goulue and her Sister at the Moulin
 Rouge
 1892. Coloured lithograph, 46 x 35 cm.

15. Jane Avril Dancing (Study for the poster
 'Jardin de Paris: Jane Avril')
 1893. Oil on cardboard, 99 x 71 cm.
 Stavros S. Niarchos collection

16. Yvette Guilbert
 1894. Ink drawing, 21 x 16 cm.
 Cabinet des Dessins, Musée du Louvre, Paris

17. Yvette Guilbert Taking a Curtain Call
 1894. Ink drawing, 15.5 x 11 cm.
 Cabinet des Dessins, Musée du Louvre, Paris

18. Le Baron Moïse (La Loge)
 1897. Lithograph, 17 x 14 cm.
 Illustration for the book 'Au Pied du Sinai',
 published 1898

19. Lucien Guitry and Jeanne Granier in
 'Amants'
 1895. Oil on cardboard, 55.5 x 43 cm.
 Musée Toulouse-Lautrec, Albi

20. Un Monsieur et une Dame
 (programme for Fabre's comedy 'L'Argent'
 at the Théâtre-Libre)
 1893. Coloured lithograph, 32 x 24 cm.

21. An Interne: Gabriel Tapié de Céleyran
 (the artist's cousin)
 1894. Ink on paper, 32 x 20 cm.
 Musée Toulouse-Lautrec, Albi

22. Woman with a Tray
 (Juliette Baron and Mlle Popo)
 1896. Lithograph (from the 'Elles' album),
 40 x 52 cm.

23. In Bed
 c.1893. Oil on cardboard, 53 x 34 cm.
 Foundation E.G. Bührle collection, Zürich

24. Sleeping Woman
 c.1896. Red chalk on paper, 20 x 27 cm.
 Museum Boymans-Van Beuningen, Rotterdam

25. Jane Avril
 1893. Lithograph, 26.5 x 21 cm.
 From the album 'Le Café-Concert'

26. Aristide Bruant
 1893. Lithograph, 26.5 x 21 cm.
 From the album 'Le Café-Concert'

27. Oscar Wilde and Romain Coolus
 (Illustration for the programme of the
 Théâtre de L'Oeuvre's double bill
 production of Wilde's 'Salome' and
 Coolus's 'Raphael'
 1896. Lithograph, 30 x 49 cm.

28. Detail of Plate 31, showing Valentin-
 Le-Desossé
 1895. Canvas, 298 x 316 cm. Musée d'Orsay, Paris

29. The Brothel Laundryman
 1894. Oil on cardboard, 58 x 46 cm.
 Musée Toulouse-Lautrec, Albi

30. Woman Combing her Hair
 1896. Oil on cardboard, 55 x 41 cm.
 Musée Toulouse-Lautrec, Albi

31. Marcelle Lender and Albert Brasseur
 in 'Madame Satan'
 1893. Lithograph, 34 x 25 cm.

32. Carnival at the Moulin Rouge: entry
 of Cha-U-Ka-O
 1896. Blue crayon, 63 x 50 cm.
 Alpheus Hyatt Fund, courtesy of the Fogg Art
 Museum, Harvard University, Cambridge, Mass.

33. The Actress, Marcelle Lender
 (in the Théâtre des Variétés 1895
 production of Hervé's operetta 'Chilpéric')
 1895. Coloured lithograph, 32.5 x 24 cm.

34. 'Elles'
 (Advertisement poster for the album)
 1896. Coloured lithograph, 61 x 48 cm.

35. At the Gaiété-Rochechouart:
 The Actress Nicolle as a Streetwalker
 1893. Lithograph, 37 x 26 cm.

36. Bartet and Mounet-Sully in 'Antigone'
 (Comédie-Française production)
 1894. Lithograph, 46 x 27 cm.

The Plates

1　Artilleryman and Girl

c.1886. Oil on tracing paper, 56 x 45 cm. Musée Toulouse-Lautrec, Albi

This dashing sketch is one of the artist's prentice works, done when he was about twenty-two. It still shows the influence of the sporting artist Princeteau, who was his first teacher, rather than that of Cormon with whom he studied later. Lautrec seems to be trying to use thinned oil paint a little as if it were watercolour – he is not yet fully in command of his medium. There are, however, things which point very clearly towards the kind of artist Lautrec was shortly to become. The high viewpoint is typical; so is the way in which he concentrates on the expression of character. The artilleryman's stance is tellingly achieved – he seems in this case to have interested Lautrec more than the girl in the foreground. The inspiration for this figure may have been a fellow-student in Cormon's atelier, Frédéric Wenz, who had served in the artillery and had retained his uniform. What is yet to come is the incisive line drawing which was later to be the vehicle for Lautrec's best perceptions.

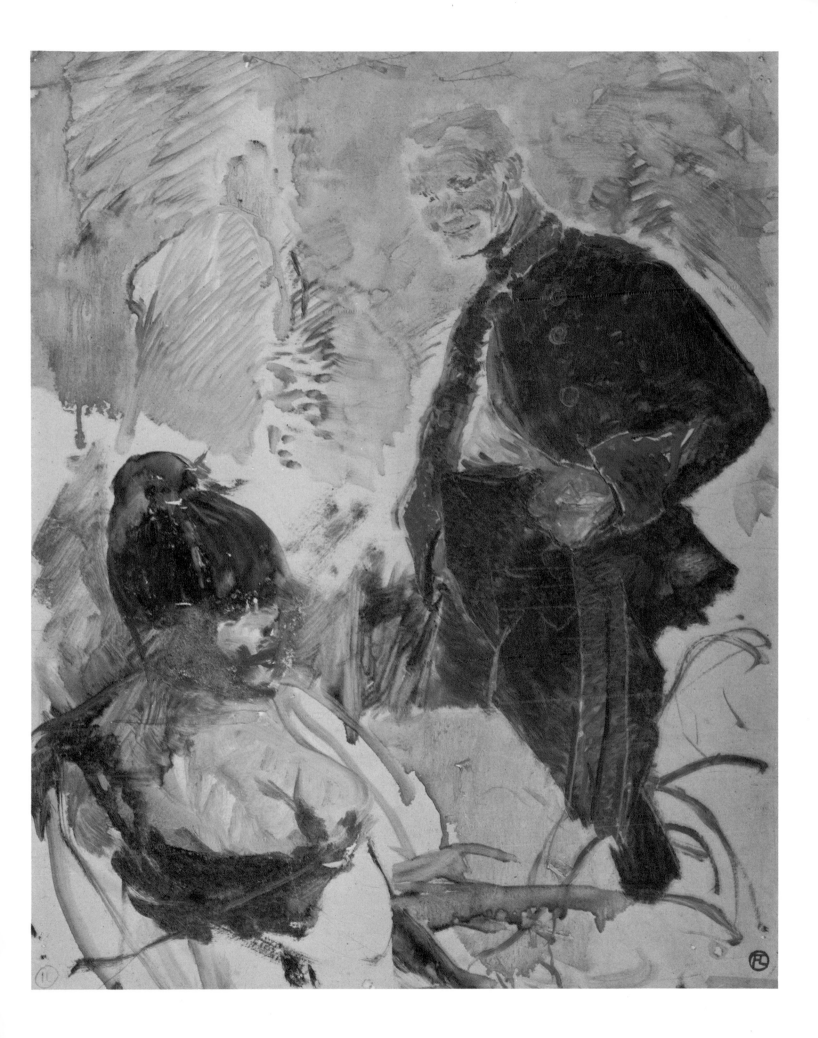

2 Emile Bernard

1885. Canvas, 54 x 44.5 cm. The Tate Gallery, London

Toulouse-Lautrec met Emile Bernard (1868-1941) when the latter was one of his fellow-students at Cormon's atelier. Bernard was subsequently expelled for insubordinate behaviour, and then went to Brittany where he met Gauguin at Pont-Aven. It was Bernard, rather than Gauguin, who invented the symbolist method of using colour to convey emotion rather than to represent perceived reality which led to Gauguin's first true masterpiece, the *Vision after the Sermon*. Bernard was later connected with the Nabis, with whom he exhibited in 1892 and 1893; he also showed at the first Salon de la Rose + Croix in 1892. Lautrec's portrait is brilliantly characterized but technically conservative. The artist has not yet evolved the method of cross-hatching strokes in thinned oil-colour which makes many of his paintings look like pastels.

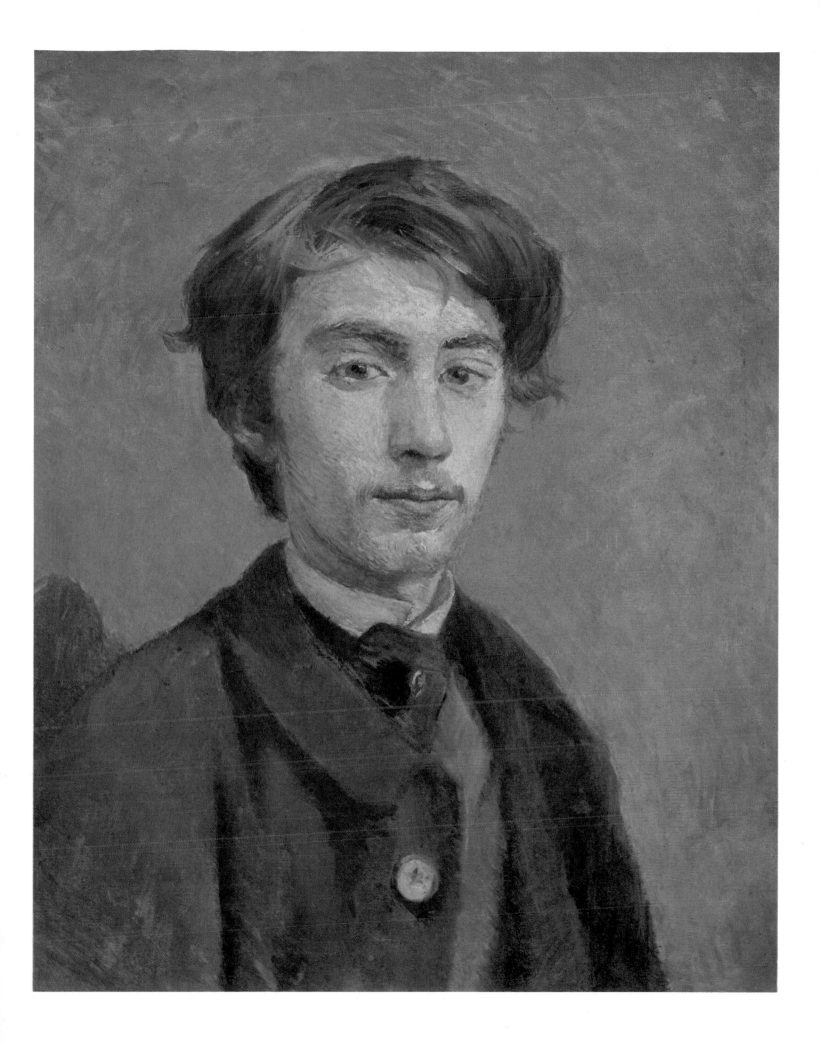

1886. Canvas, 54 x 45 cm. The Ny Carlsberg Glyptotek, Copenhagen

Fig. 11
The Morning After

1889. India ink and blue
chalk, 48 x 63 cm. Musée
Toulouse-Lautrec, Albi

Suzanne Valadon (1867-1938) began life as an acrobat, then, after being injured in a fall, worked as a dressmaker and artist's model. She sat for Renoir and Degas as well as for Lautrec. For a while she was Lautrec's mistress, and it was he, as much as Degas, who encouraged her efforts to turn artist herself. These two representations of Valadon (known to Lautrec not as Suzanne but as 'Maria') are a study in contrasts. One is a relatively straightforward portrait, in which his characteristic technique of cross-hatched strokes begins to manifest itself, the other is a 'character study' using a particular model as a pretext. *The Morning After* is a preliminary drawing for a lithograph on a theme which interested many of Lautrec's contemporaries. It is closely related in mood to *A la Mie* (Plate 8).

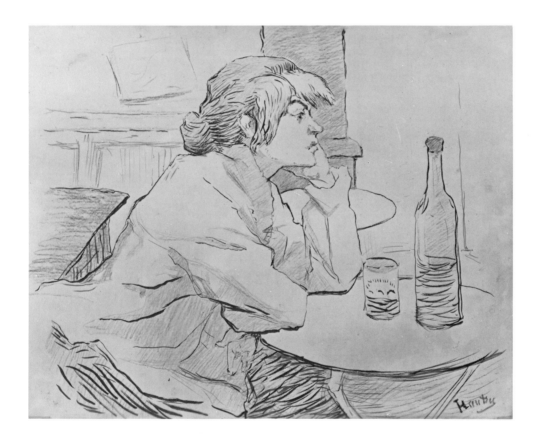

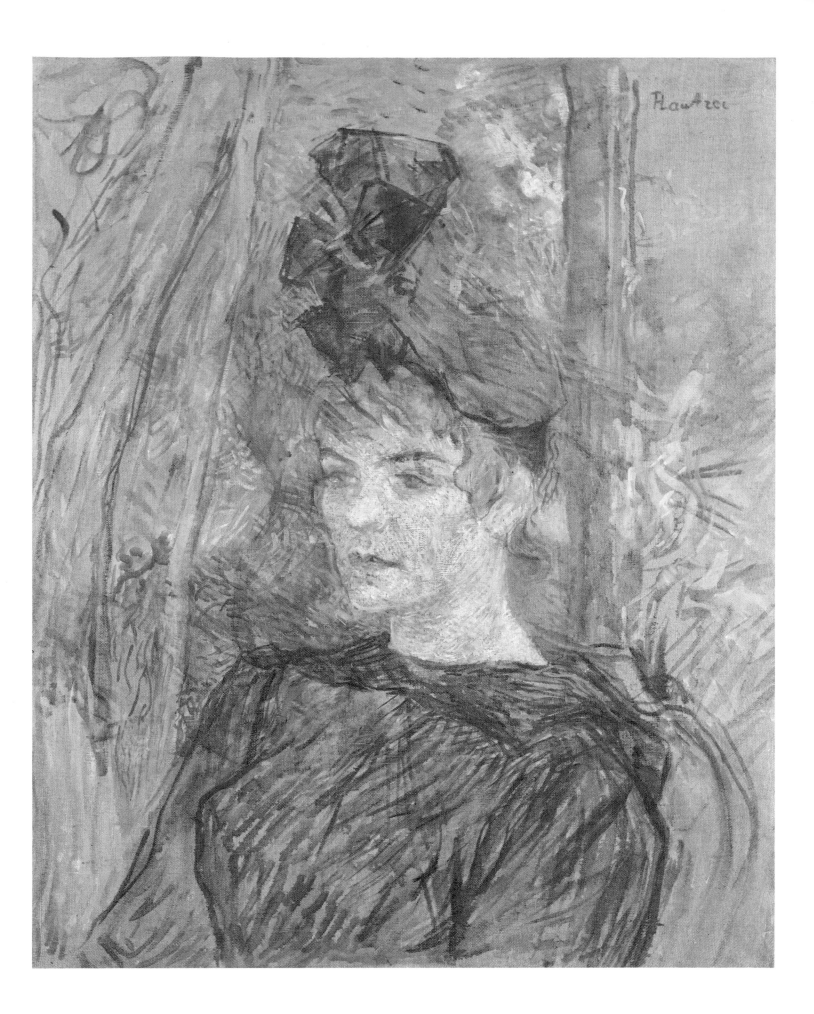

4 Jeanne Wenz

1886. Canvas, 81 x 59 cm. The Art Institute of Chicago

Jeanne Wenz was the mistress of Lautrec's fellow-student at Cormon's, Frédéric Wenz, and had taken her lover's name. The painting is in many respects very close in style to the portrait of Emile Bernard, which was painted only slightly earlier (Plate 2). Despite its relative conservatism of technique, it does illustrate one habit which was to appear frequently in Lautrec's more mature paintings – his liking for the profile view. Here the sitter is very nearly, but not completely, in profile, as if the young Lautrec had not as yet summoned up the courage to choose the viewpoint which attracted him, instead of a more conventionally flattering one. Character and expression, however, already matter more to him than making a pretty image.

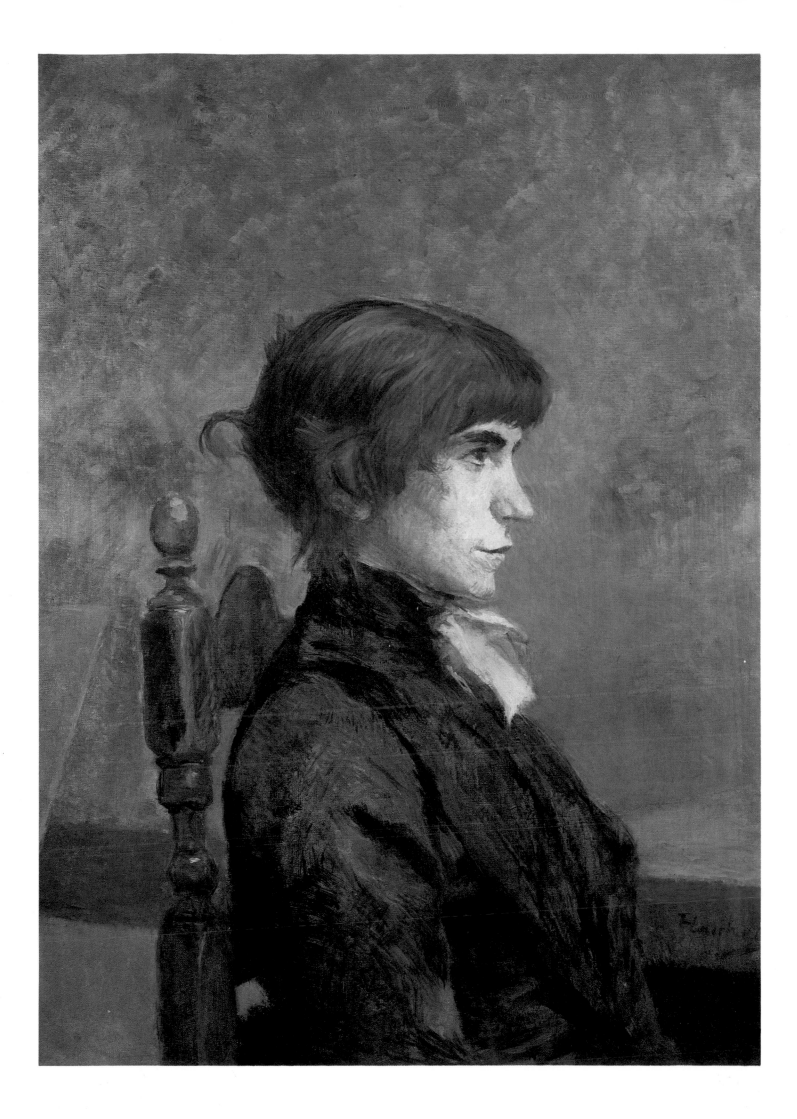

Emile Davoust

1889. Cardboard, 45 x 35 cm. Kunsthaus, Zürich

Lautrec always had a love of ships and the sea, perhaps because swimming and sailing were sports he could manage to participate in, despite his crippled state. In 1880, when he was convalescing at Nice from his second accident (he broke first his left leg, then his right) he spent his time drawing maritime scenes. And from 1886 onwards he took regular summer holidays by the sea, generally staying with a friend called Fabre who had a cottage at Taussat, in the bay of Arcachon, near Bordeaux. Lautrec did little painting during these summer breaks (he detested landscape painting and soon gave it up after a few early experiments) but in 1889 he did produce this telling portrait of Emile Davoust, the skipper of the small yacht *Le Cocorico* which he hired that year. The background represents the closest he came to the true Impressionists, and particularly to Manet.

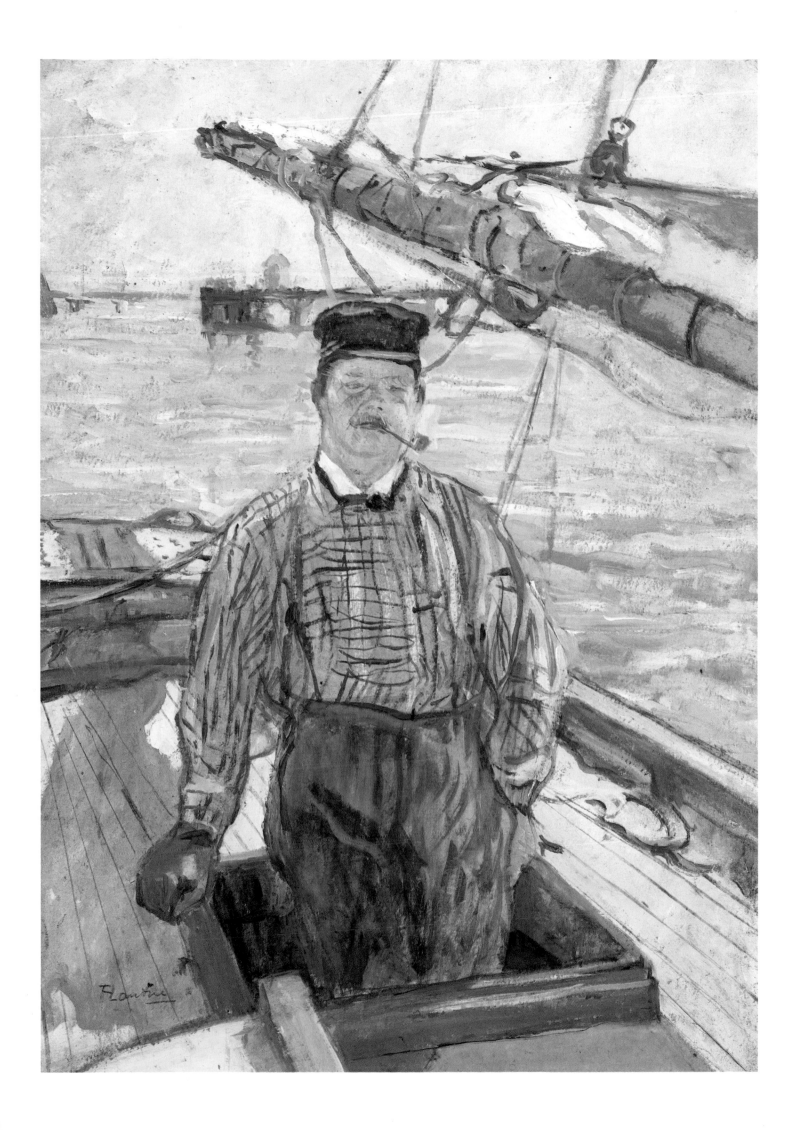

Gabrielle

1891. Cardboard, 67 x 53 cm. The National Gallery, London

Most of Lautrec's portraits of women are of unknowns – street-girls and small-time entertainers. The only thing we know about Gabrielle, in addition to her first name, is the fact that she was a dancer. Lautrec did two particularly successful portraits of her. They were painted in a large, rather neglected garden, known as 'the garden of Père Forest', which occupied a space at the corner of the rue Caulaincourt and rue Forest, facing the Boulevard de Clichy. The owner was a retired elderly business-man with a passion for painting and for archery – his nickname was 'the Archer of Montmartre'. He owned a set of butts for archery, and also a small bar (a facility which would have appealed to Lautrec) and gave the artists he knew the run of his garden. In summer Lautrec often used it as an outdoor studio.

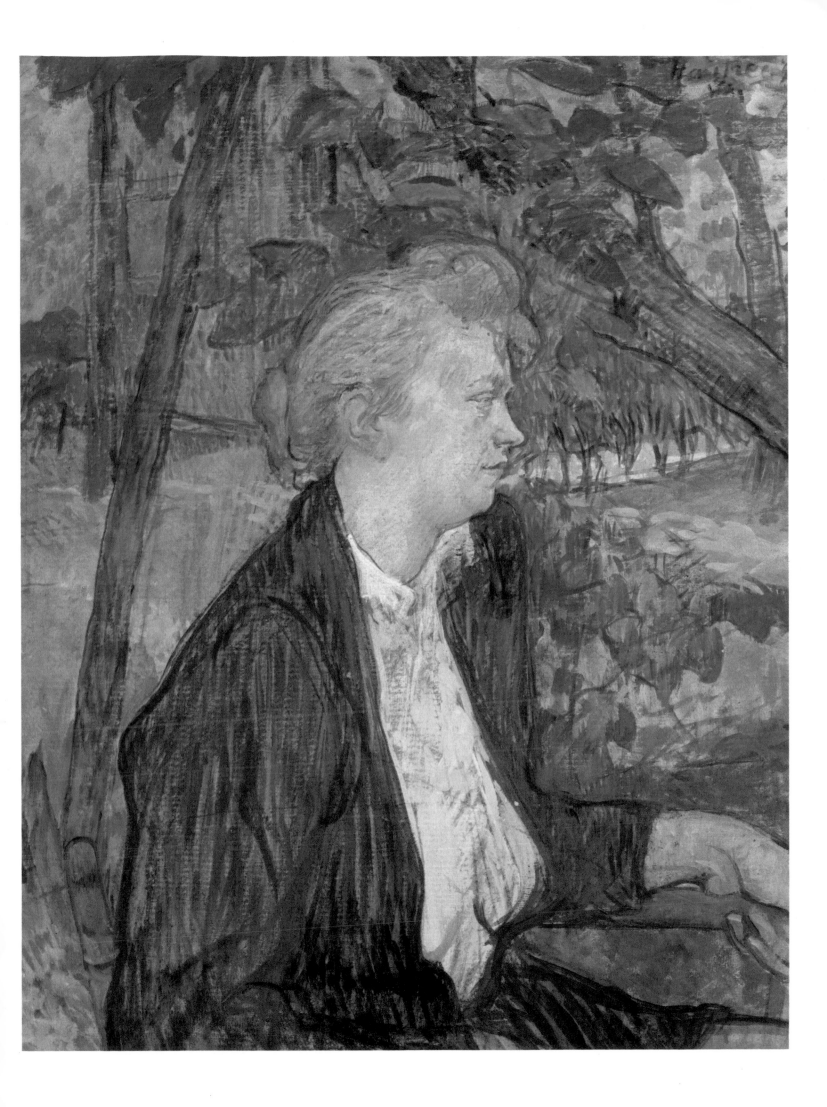

Justine Dieuhl

c.1891. Cardboard, 74 x 58 cm. Musée d'Orsay, Paris

This is another of the portraits painted in Père Forest's garden. Though the sitter's full name is known we have no details about her – her costume suggests that she was working-class, and perhaps a 'pier-reuse' or street-walker. Lautrec catches her slightly self-conscious alertness very well. He is known to have taken much greater trouble with his portraits than he did with his paintings of the Moulin Rouge and other places of entertainment which now account for the greater part of his popular reputation. He made numerous studies of the sitter before committing himself to a final version. One notable feature of these portraits, though they were painted out-of-doors, is Lautrec's indifference to effects of light. Another, particularly conspicuous here, was the skill he developed in drawing the sitter's hands. Justine Dieuhl's, large, knobbly and rather work-worn, tell us more about her than her face.

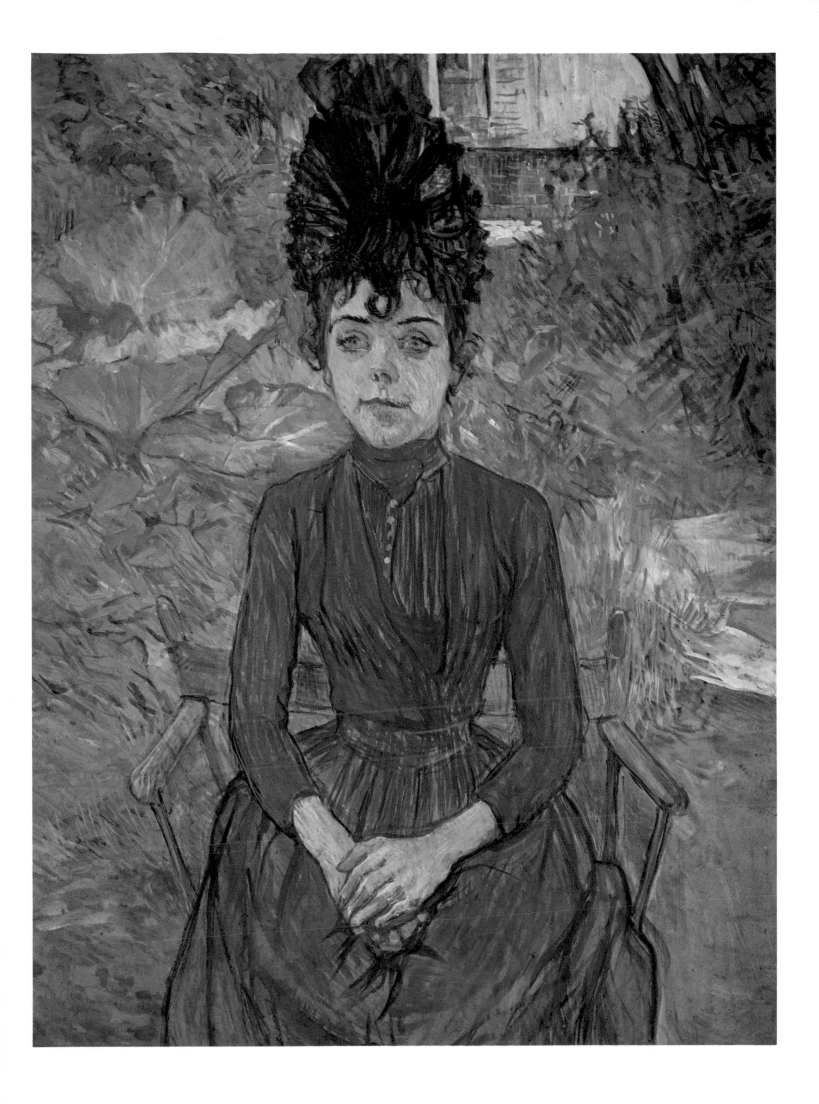

8 'A la Mie'

1891. Cardboard, 53 x 68 cm. Museum of Fine Arts, Boston

The picture is a variation by Lautrec on a theme already used by Degas. The composition derives from the latter's *L'Absinthe* of c.1876 where once again two depressed-looking figures are seen seated at a café table, studiously ignoring one another. The picture by Degas is in fact the more daring of the two, as there the male figure is pushed to the very edge of the composition. Here the spatial relationships are less imaginatively handled, though Lautrec, like Degas, uses objects such as bottles and glasses as spatial markers to establish points of reference. The model for the male figure was Lautrec's boon companion Maurice Guibert, a dilettante artist and photographer who earned his real living as a salesman for Moët & Chandon, the champagne firm. He often accompanied Lautrec on his nocturnal ramblings and appears in a number of his paintings (Plates 33 and 34).

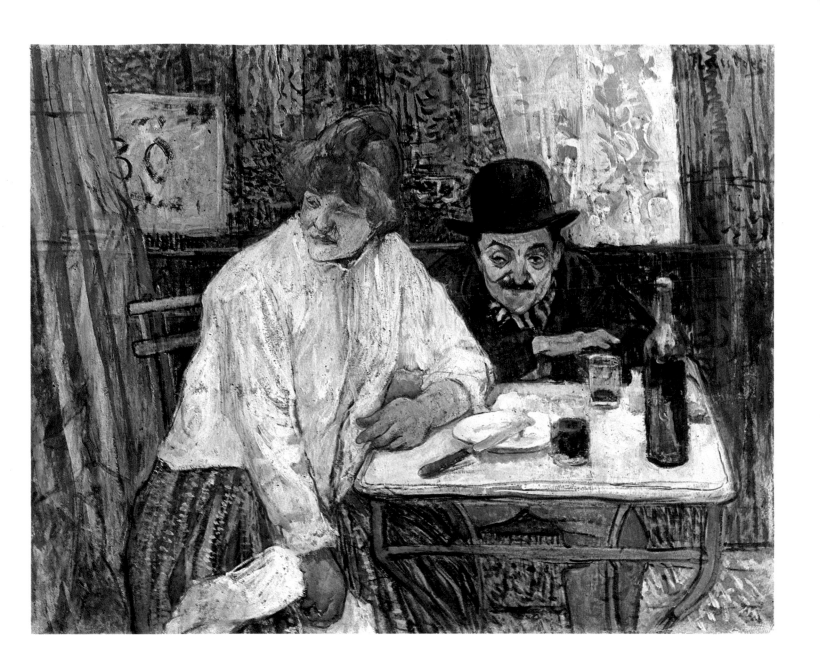

Moulin Rouge – La Goulue

1891. Poster (coloured lithograph), 194 x 122 cm.

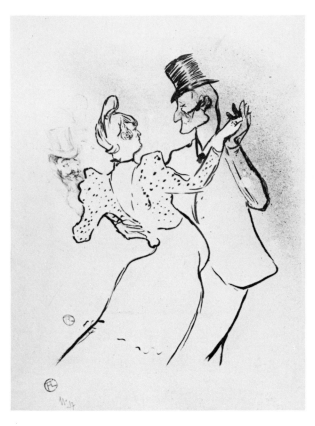

Fig. 12
**La Goulue
Waltzing with
Valentin-le-
Désossé**

1894. Lithograph,
30 x 23 cm.

The Moulin Rouge scored an immediate success when it opened its doors in 1889, chiefly because it was bigger, brighter and brasher than any of its older rivals, such as the Elysée-Montmartre. It advertised itself with a large wooden mill on the roof, brightly illuminated at night, and offered a series of side-shows as well as a large dance-hall. Its first big attraction was the Pétomane, who concealed himself within a papier-mâché elephant and gave vent to a series of musical farts. Its first poster was by Chéret, virtually the inventor of the coloured lithographic poster as we now know it.

When the attractions of the Pétomane started to pall, the owner, Charles Zidler, seduced the famous Naturalist Quartet away from the Elysée-Montmartre – its best-known members were La Goulue (the Glutton), and Valentin-le-Désossé (Fig. 12). Louise Weber, otherwise known as La Goulue, had started life as a laundress, and was discovered by Lautrec when she first appeared at the smaller and more rustic Moulin de la Galette. He was instantly fascinated by her ferocious energy and was delighted when Zidler asked him to do a poster for his latest attraction. The poster scored a huge success, and is still Lautrec's best-known image. It shows the effect of his study of Degas and of Japanese prints, but has a visual energy which perfectly translates the style of Weber's dancing.

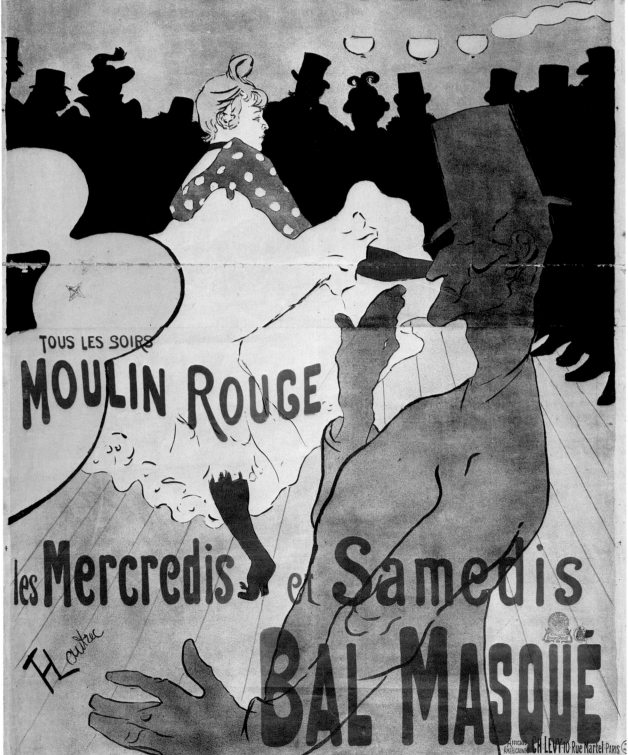

Woman with a Black Feather Boa

c.1892. Cardboard, 53 x 41 cm. Musée d'Orsay, Paris

This was the first of Lautrec's pictures to find its way into a public collection. It entered the Luxembourg in 1902, the year after the painter's death, as a gift from his mother, Countess Adèle. Léonce Bénédite, the then curator of the collection, was offered numerous other works by the artist at the same time and refused them all. We can see why this one in particular might have attracted Bénédite's attention. It has the sketchiness and slightly flashy brilliance which were then associated with Lautrec. Its technique is very typical – thinly painted in oil on cardboard, to give the effect of paste. We can compare it to the even sketchier portrait of Mr Warrener (Plate 14). Lautrec seems to have evolved the technique, which is peculiar to himself, as a means of getting effects similar to those he found in the pastels of his admired Degas.

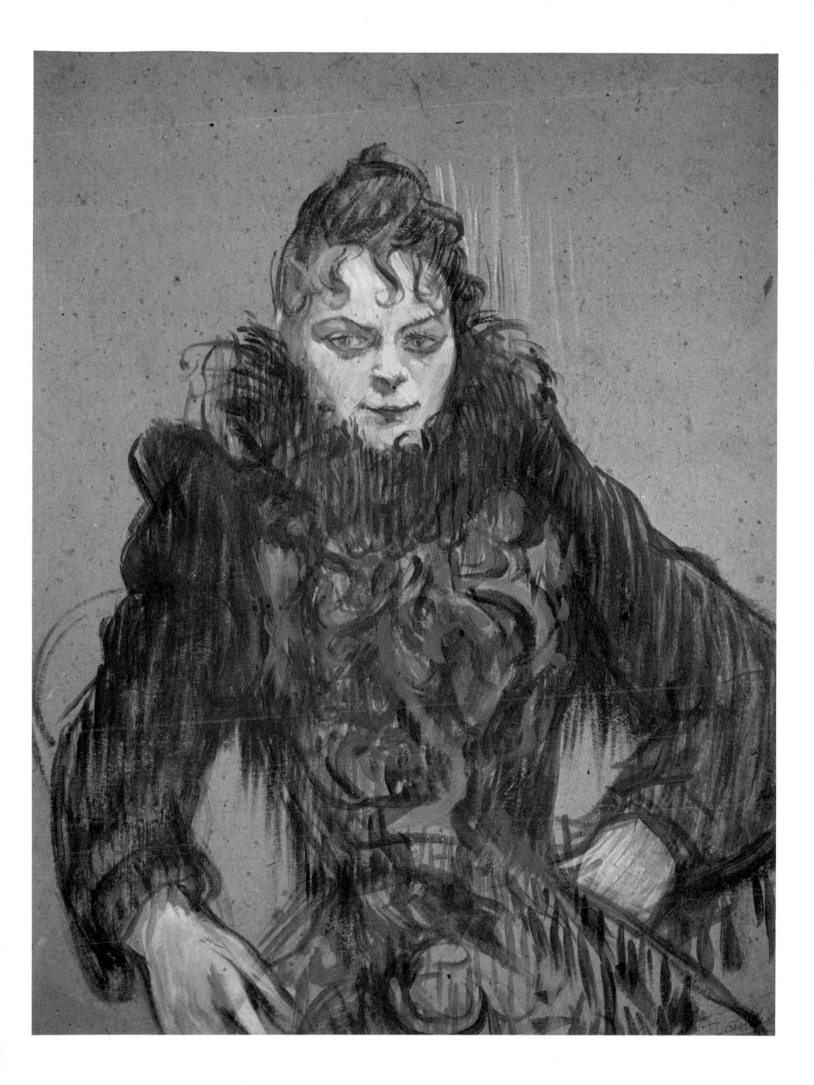

11 Woman with Gloves (Honorine P.)

c.1890. Cardboard, 54 x 40 cm. Musée d'Orsay, Paris

The sitter's name was Honorine Platzer, and once again nothing is known about her. She seems to be of much higher social class than Justine Dieuhl. Lautrec is here fully in command of his stylistic method, and the sense of design he shows in this picture is particularly happy, as is the incisive drawing of the profile – for once that of a genuinely attractive woman. Lautrec was once asked: 'Why do you make all your women so ugly?', and replied tartly: 'Because they are!' One particularly interesting feature of this portrait is that it seems to have served as a kind of trial run for the representation of Jane Avril in Lautrec's poster for *Divan Japonais* (Plate 19). The affinities are very striking, not least the importance given to a large hat. It is interesting to see how Lautrec, portraying Avril, makes the pose more rigid and alters the position of the arms to give a sharper impression of alertness.

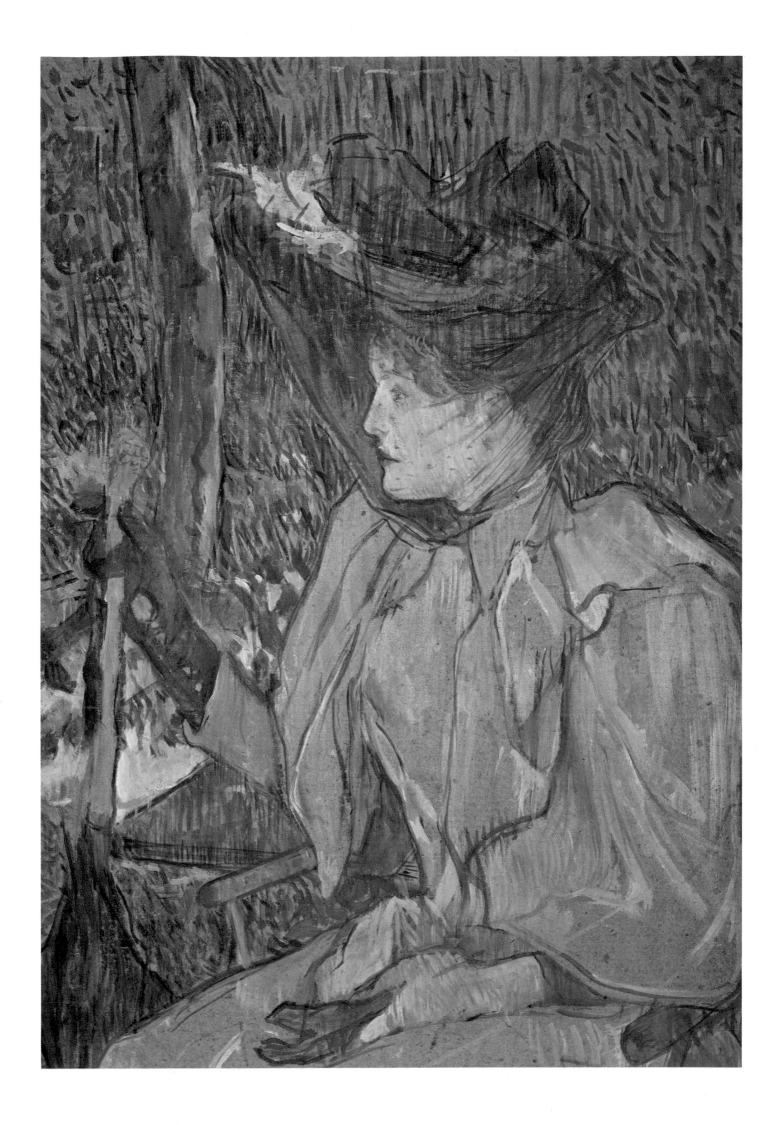

At the Moulin Rouge: Two Women Dancing

1892. Cardboard, 93 x 80 cm. National Gallery, Prague

Montmartre had started off as a kind of rustic resort, a place where Parisians went for a change of air. By Lautrec's day it was attracting members of the underworld and other outsiders. In particular, there was a lot of lesbianism among the professionals who danced at the various dance-halls. La Goulue was that way inclined, and so was the female clown Cha-U-Ka-O (*see also* Plates 35 and 39). Cha-U-Ka-O appears here in mufti – the right-hand figure of the two women waltzing together. Also visible are the dancer Jane Avril (*see* Plate 17, Fig. 15) with her back to the spectator, and two of Lautrec's male friends, to the extreme left the French painter François Gauzi, and to the extreme right the decadent Australian Charles Conder, also a painter. The picture is one of the first statements of Lautrec's fascination with lesbian activity, which later seems to have become obsessional. Many of the brothel scenes stress this element (Plate 26, Fig. 23), and towards the end of his life Lautrec became a regular habitué of lesbian bars, especially one called 'Le Souris'. He is also reported to have organized lesbian orgies, with himself as voyeur.

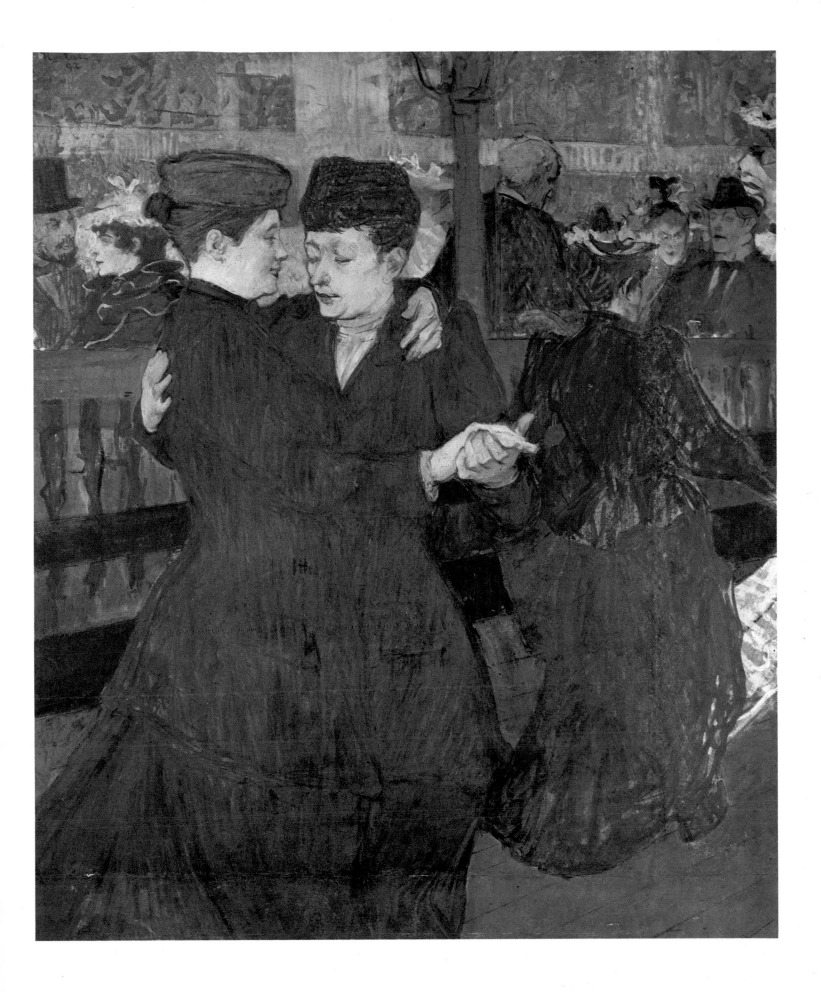

Reine de Joie

1892. Poster (coloured lithograph), 136 x 91 cm

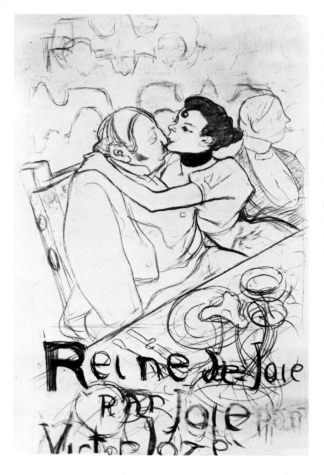

Fig. 13
**Study for the
Poster 'Reine de
Joie'**

1892. Charcoal,
152 x 105 cm. Musée
Toulouse-Lautrec, Albi

This poster for a totally forgotton novel by Louis Joze, a friend of Lautrec's who was in some way or other mixed up with the then fashionable anarchism, powerfully illustrates Lautrec's gifts as a graphic designer. The diagonal of the table-cloth splits the available surface into two zones, and enables the artist to give a feeling of recession without employing either true perspective or even chiaroscuro. The use of areas of black, for the man's dress-suit and the woman's hair, as well as for the broad ribbon round her neck, is crucial in helping to focus our attention on the two principal figures in the design. Also interesting is the use of non-naturalistic colour, and especially of coloured outline – red for the woman's arm and profile, green for the head of the man she is embracing. The difference in their respective flesh tones is thus neatly symbolized, and a difference in character is also suggested. The somewhat irregular hand-drawn lettering adds vitality to the whole. A preliminary drawing for the poster demonstrates Lautrec's absolute certainty in rendering the two heads, as well as showing minor hesitations over less important details.

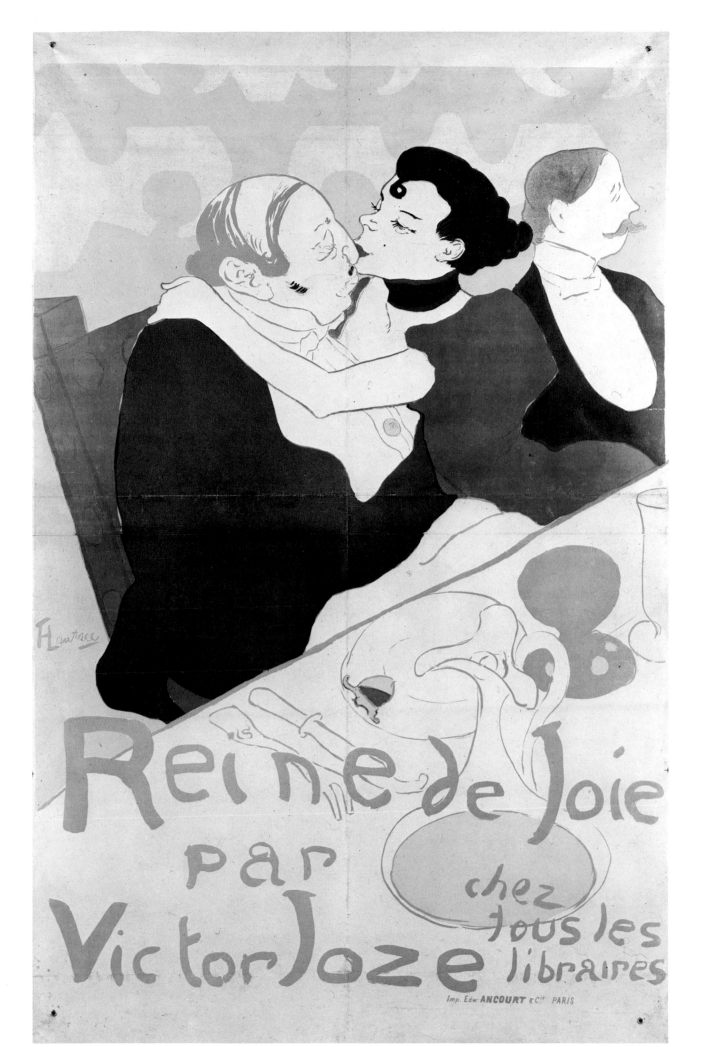

Head of the Englishman at the Moulin Rouge

1892. Cardboard, 57 x 45 cm. Musée Toulouse-Lautrec, Albi

This is generally considered to be one of the finest of Lautrec's portrait studies. It represents Mr J.P.T. Warrener from Lincolnshire (the name is sometimes given as 'Warner'). As in many of his studies of this type, Lautrec left large areas of the brownish cardboard on which it was painted completely bare. The thinned oil-colour is used as a graphic medium, and the forms of the head are created by the meshing of very visible brush-strokes. The study became the basis of a painting, and this in turn provided the model for a masterly lithograph (Plate 15). Its two successors convey expertly the atmosphere of the Moulin Rouge. What we get here, where the man's head is seen in isolation, is a more concentrated reminder of the artist's own aristocratic connexions and sympathy with the aristocratic life-style. Warrener is obviously a gentleman – and equally obviously not an intellectual. He is, however, the sort of man who would probably have felt quite at home (language difficulties permitting) in the artist's own family circle.

The Englishman at the Moulin Rouge

1892. Lithograph, 47 x 37 cm.

The Englishman at the Moulin Rouge, together with an image of *La Goulue and her Sister*, was Lautrec's first venture into lithograph as a medium for making independent prints. He shows an instinctive grasp of both the limitations and possibilities of the medium. The lithograph is closely based on a painting of the same subject, with the same figures in the same relationship to each other. But the main figure is now back-lit, just as the dancer Valentin is in the poster advertising the Moulin Rouge (Plate 9). Figure and outline are reduced to two tones of one colour, and the intricate internal modelling, such a feature of Lautrec's first portrait sketch (Plate 14), has disappeared. The two flirtatious women Warrener is talking to are by contrast built up in areas of bright colour. Yet it is still the man who remains the controlling centre of the composition, because his is the only face of the three which appears complete. Both women's mouths are almost obscured, and this somehow makes them passive rather than active in the design.

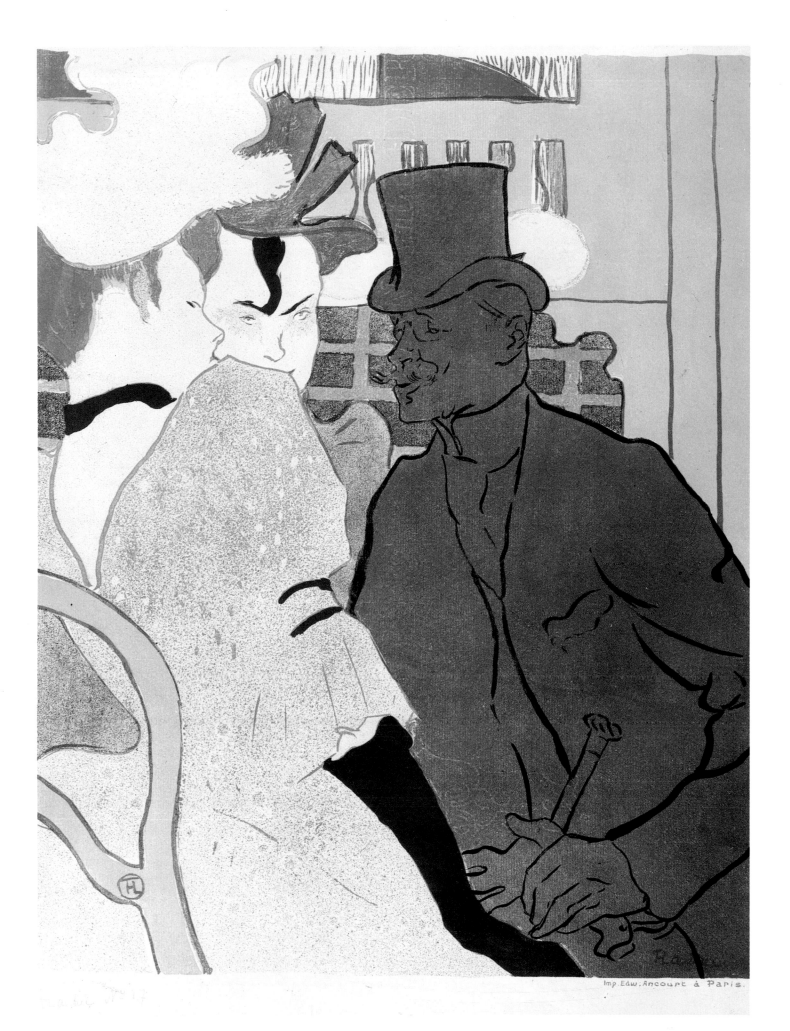

Imp. Edw. Ancourt à Paris.

At the Moulin Rouge

1892. Canvas, 123 x 140.5 cm. The Art Institute of Chicago

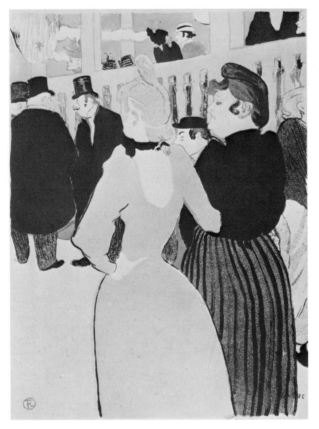

Fig. 14
La Goulue and
her Sister at
the Moulin Rouge

1892. Coloured lithograph,
46 x 35 cm.

This large picture illustrates very precisely some of the important traits of Lautrec's work. For example, one of the most prominent features of the composition – and a very startling one – is the large female head looking out of the painting to the right. This is cropped in a fashion which suggests the influence of photography (something Lautrec would have learned from Degas). But there are also other characteristics of great interest. One is the fact that the scene is viewed slightly from above – this often occurs in Lautrec's work, as if to compensate for the fact that he was himself so short. The picture also offers a whole repertoire of characters, many of whom appear in other paintings by Lautrec. Seated at table are the literary and musical critic Edouard Dujardin (*see* Plate 19), the Spanish dancer La Macarona, the Montmartre photographer and entertainer Sescau (Plate 34) and Maurice Guibert (Plates 33 and 34). In the background are two oddly assorted couples – the diminutive Lautrec himself with his tall shambling cousin Gabriel Tapié de Céyleran (Plate 22), and La Goulue and her 'sister' (in reality her lesbian lover), La Môme Fromage, another of the dancers at the Moulin Rouge. The two latter were also the subject of a quite separate composition (Fig. 14).

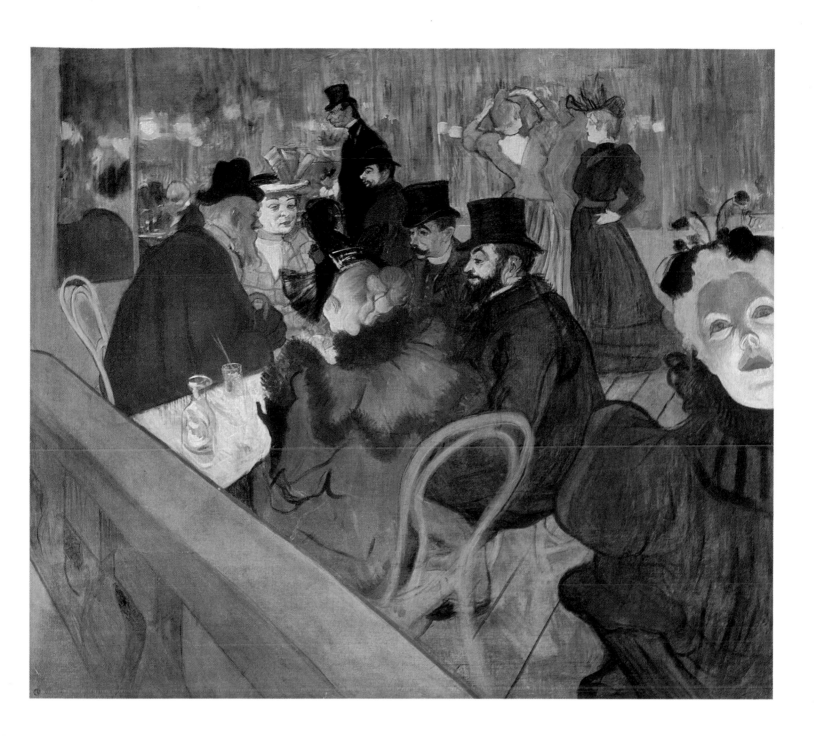

1892. Oil and pastel on cardboard, 102 x 55 cm. Courtauld Institute Galleries, London

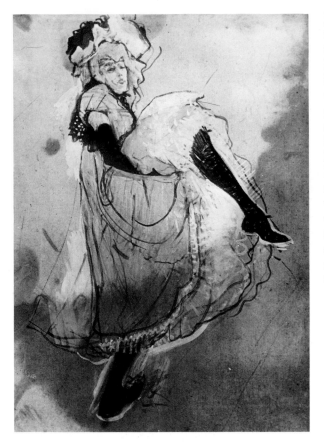

Fig. 15
Jane Avril Dancing
(Study for the
poster 'Jardin de
Paris: Jane Avril')

1893. Oil on cardboard,
99 x 71 cm.
Stavros S. Niarchos
collection

Jane Avril was the daughter of a Paris *demi-mondaine* and an Italian noble-man (an identical ancestry to that of the poet Guillaume Apollinaire). Her mother was a half-crazy termagant, and Jane Avril herself spent a period of her early life in La Saltpêtrière suffering from a nervous breakdown largely induced by her mother's antics. She was dicovered by Lautrec when she was only a chorus girl at the Moulin Rouge. She was rapidly promoted, partly at his urging, to the role of star dancer. One of her attractions was that she managed to be curiously refined and decorous in the midst of the brassy vulgarity of her setting. Her incongruous nickname was 'La Mélinite' (or 'Dynamite') and she was described by Maurice Joyant, Lautrec's most authoritative biographer, as dancing 'like an orchid in ecstasy'. When Lautrec became truly interested in a performer, as he did with Jane Avril, he wanted to record the private as well as the public self, which is what he is doing in the main picture. The image of Avril dancing (Fig. 15) is a study for a poster he did for her, and it shows her doing her speciality, a set known as the *port de bras* with both hands locked under her thigh while the leg itself waved from side to side – a variation on La Goulue's energetic high kick.

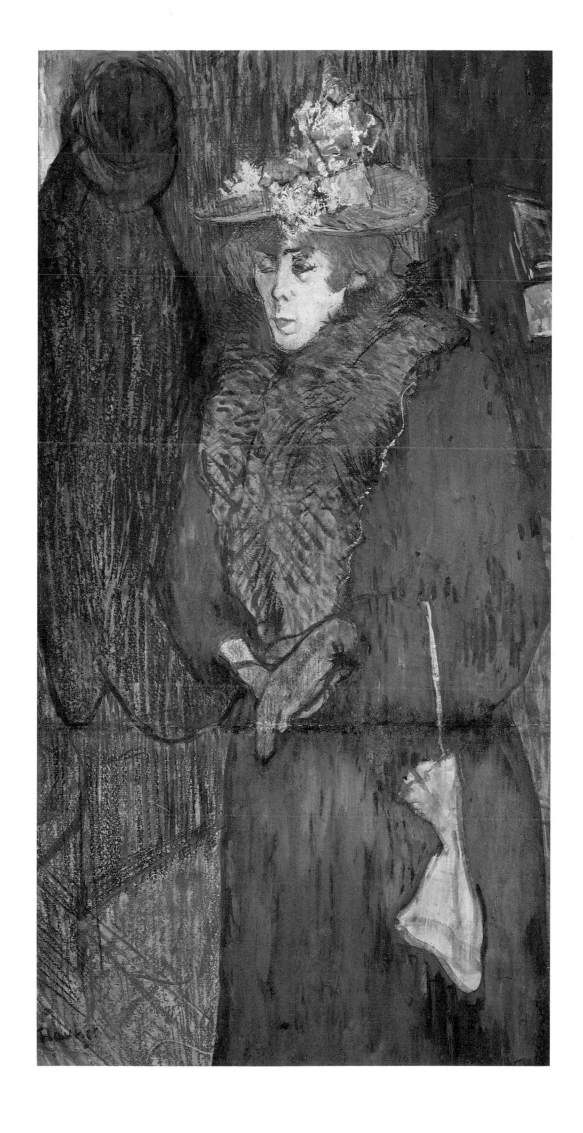

1893. Watercolour, 42 x 23 cm. Rhode Island School of Design, Providence

Fig. 16
Yvette Guilbert

1894. Ink drawing,
21 x 16 cm.
Cabinet des Dessins,
Musée du Louvre, Paris

Fig. 17
**Yvette Guilbert
Taking a Curtain
Call**

1894. Ink drawing,
15.5 x 11 cm.
Cabinet des Dessins,
Musée du Louvre, Paris

The closest of all Lautrec's relationships with the performers he portrayed were probably those with Yvette Guilbert, shown here, and with Aristide Bruant (Plate 29), since these were also the closest to being his intellectual equals. He eventually made Yvette Guilbert the subject of two albums of lithographs. However, their relationship did not start propitiously. He was introduced to her, when she was already well-established, by her song-writer Maurice Donnay. Lautrec wanted to do a poster of her, but she reacted unfavourably to his sketches, writing as follows:

'Dear Sir,
As I told you, my poster for this winter is already ordered and is nearly finished. So we'll have to put it off till another time. But for heaven's sake, don't make me so dreadfully ugly! A little less, sir, if you please! . . . Many people who come to see me shriek with horror at the sight of the coloured sketch . . . Not everyone can see the artistic side of it . . . oh, well! With grateful thanks,

Yvette.'

Lautrec's hasty preliminary sketches illustrate the merciless incisiveness of his vision.

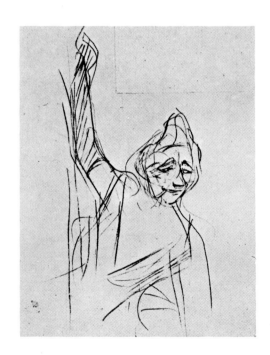

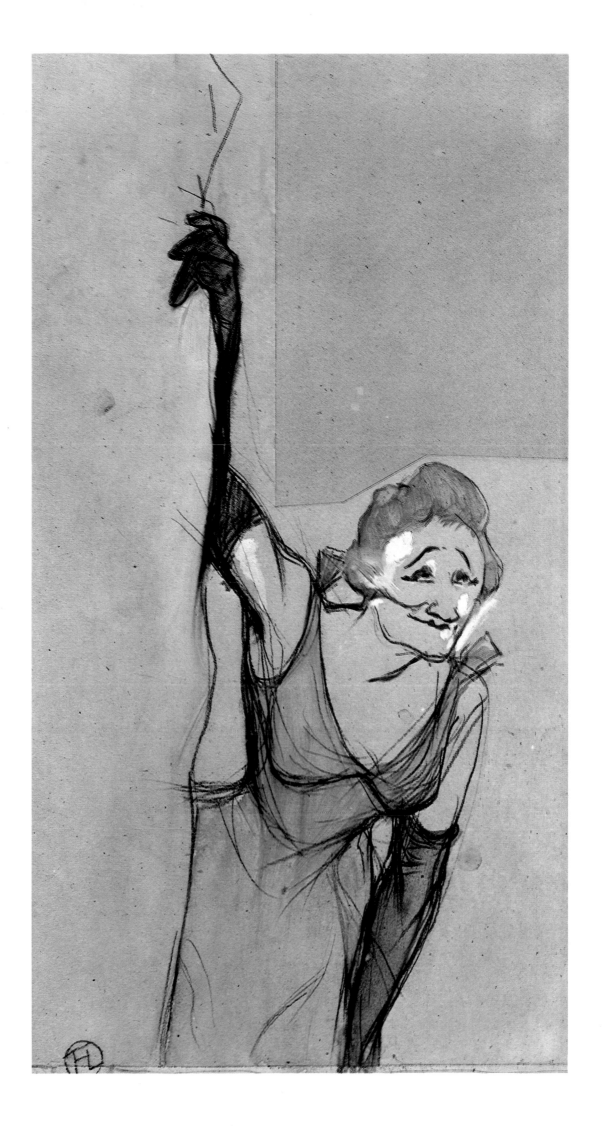

1893. Poster (coloured lithograph), 79.5 x 59.5 cm.

The Divan Japonais was a small cabaret with an elaborate décor in mock-Japanese style. Thanks to its intimate scale, it was ideally suited to the talents of Yvette Guilbert, who had a notoriously weak voice. She appears here in the background of the scene, instantly recognizable by the long black gloves which were her trademark, though the head of the figure has been cut off. The principal figure, an elegantly garbed spectator, is Jane Avril, and she is accompanied by the literary and musical critic Edouard Dujardin, who also appears in *At the Moulin Rouge* (Plate 16). Dujardin was a prominent figure in Symbolist circles, as editor of the *Revue Indépendante* and co-editor of the *Revue Wagnérienne*. He was Mallarmé's most blindly enthusiastic devotee, a fact for which the latter was not altogether grateful, describing his disciple as 'the offspring of an old sea-dog and a Brittany sea-cow'. Scenes showing spectators at some kind of theatrical representation had been made popular by the Impressionists, notably Degas and Renoir, and Lautrec used the theme on several occasions. Another example, reproduced here (Fig. 18) was an illustration to Georges Clemenceau's book about the Polish Jews, *Au Pied du Sinai*, published in 1898, perhaps the most unexpected of all Lautrec's commissions as an illustrator.

Fig. 18
Le Baron Moïse
(La Loge)

1897. Lithograph,
17 x 14 cm.

1893. Cardboard, 51 x 36 cm. Private collection

Though the subject's name is always given thus, he is more likely to have been called 'Prince' and to have been English or Irish. There was a great vogue in the Parisian cabarets and music-halls of this period for performers from across the Channel. Three others whom Lautrec portrayed were the dancer May Milton (a great friend of Jane Avril and nicknamed 'Missaussi' from Avril's habit, when accepting an invitation, of saying 'And may I bring Miss too?'), May Belfort and the mimic Cissy (or Cécy) Loftus (Fig. 5). In any case Lautrec himself was an enthusiast for all things English and some of his favourite bars in Paris were those where the English community congregated. This sketch shows his unequalled gift for catching a performer in action – we see it again in the lithograph of Lucien Guitry and Jeanne Granier (Fig. 19). *M. Praince* is less the portrait of a man than a portrait of the role which that man has for the moment assumed and is intent on projecting to an audience. The focus is on the mask-like countenance, harshly modelled by theatrical lighting. Compare the large full-face head at the extreme right of *At the Moulin Rouge* (Plate 16).

Fig. 19
Lucien Guitry and Jeanne Granier in 'Amants'

1895. Oil on cardboard,
55.5 x 43 cm. Musée
Toulouse-Lautrec, Albi

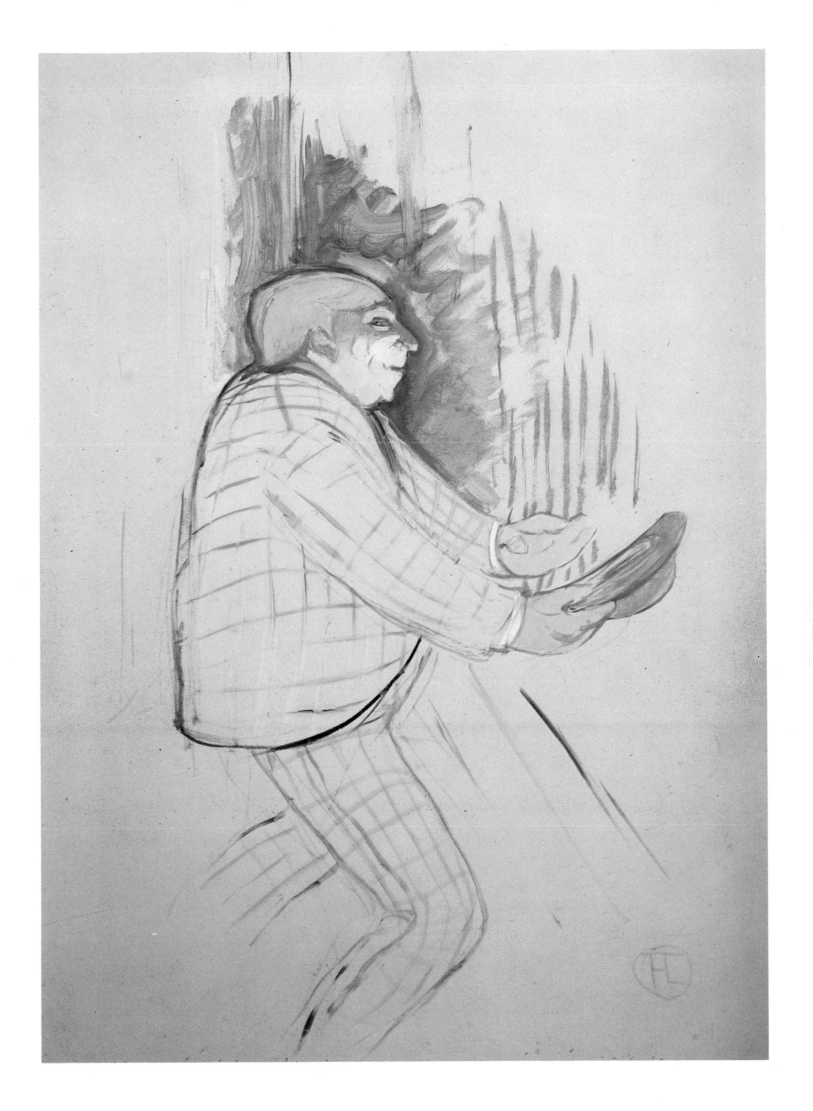

21 Confetti

1894. Poster (coloured lithograph), 54.4 x 39 cm.

Lautrec's poster design *Confetti*, undertaken for an English firm, is nevertheless the very essence of Parisian gaiety. It shows how thoroughly he had absorbed all the lessons which the other poster-designers of his day – and Chéret in particular – had to impart, and how far he was able to surpass them. Especially striking is the way in which Lautrec flouts our gravitational sense – the girl who occupies the main place in the design is floating, not standing or even running. The hands which pelt her with confetti are divorced from any possible body. It is said that the model was the actress Jeanne Granier, also portrayed by the artist in a lithograph showing a scene from the play *Les Amants*, in which she appeared with Lucien Guitry (Fig. 19). Lautrec frequently supplied designs for theatre-programmes as well as illustrating plays, and, despite their small scale, these can be just as bold as his posters. The programme illustrated here for comparison (Fig. 20) uses one of Lautrec's favourite spatial devices – the diagonal of a table top. Like *Confetti* the programme design for Fabre's *L'Argent* makes much play with the broad areas of a loosely-flowing garment, an amorphous shape whose form is articulated almost entirely by the masterly use of outline.

Fig. 20
Un Monsieur et une Dame

1893. Coloured lithograph, 32 x 24 cm.

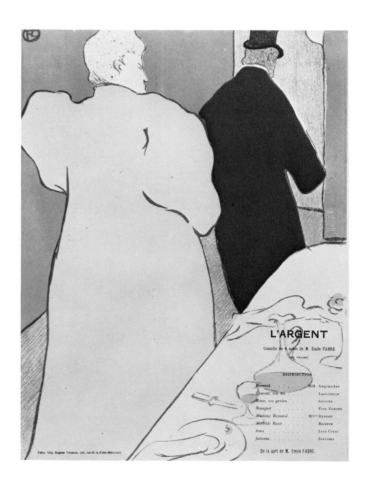

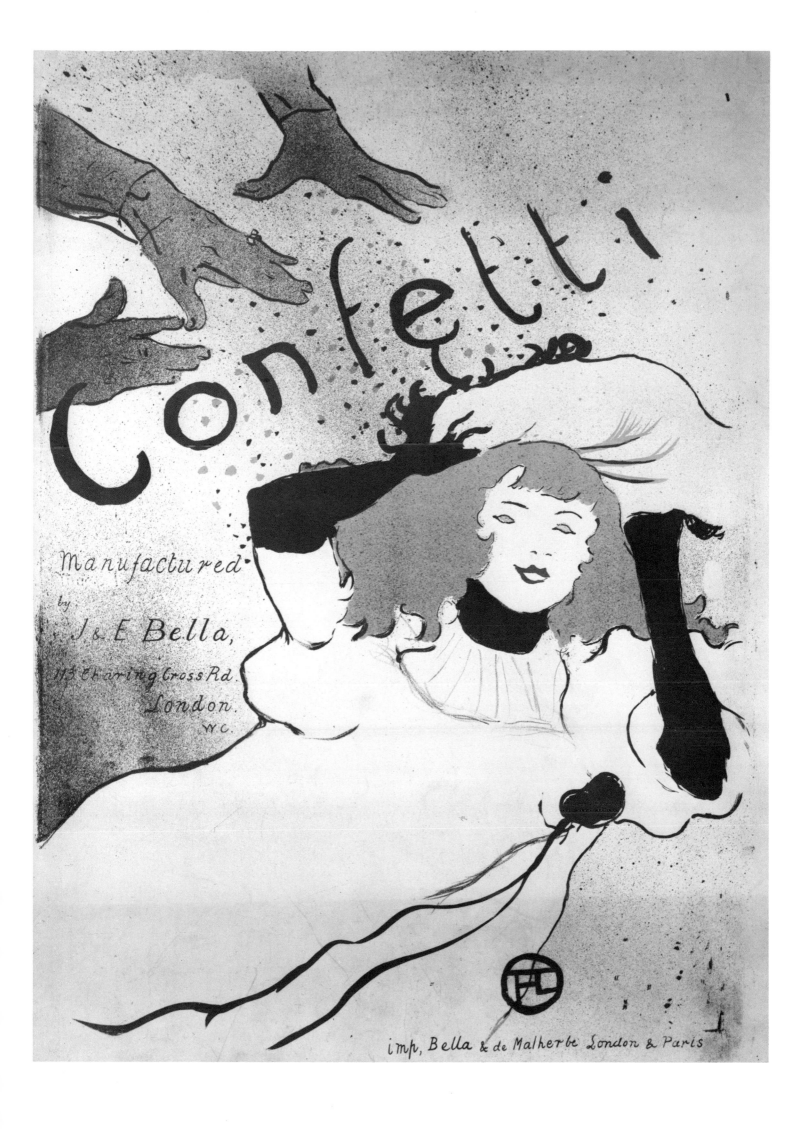

Dr Gabriel Tapié de Céleyran

1894. Canvas, 110 x 56 cm. Musée Toulouse-Lautrec, Albi

Gabriel Tapié de Céleyran was Lautrec's cousin, and his constant companion on his nocturnal ramblings around Montmartre. He was as tall as Lautrec was short, and as inarticulate as the latter was voluble. Lautrec delighted in the contrast, and made his cousin the butt of many jokes. The painted portrait has a strong element of caricature, and clearly developed out of some of the many lightning studies Lautrec made of Tapié de Céleyran (Fig. 21). The picture shows the young doctor in reasonably 'respectable' surroundings – he is shambling through the foyer of the Comédie-Française. Tapié de Céleyran remained unruffled by Lautrec's sallies at his expense, and was a constant admirer of his art. He also concerned himself with more practical matters. It was he, for example, who was partially responsible for Lautrec's incarceration in a mental home at Neuilly after his fit of delirium tremens in February 1899.

Fig. 21
An Interne:
Gabriel Tapié de
Céleyran

1894. Ink on paper,
32 x 20 cm. Musée
Toulouse Lautrec, Albi

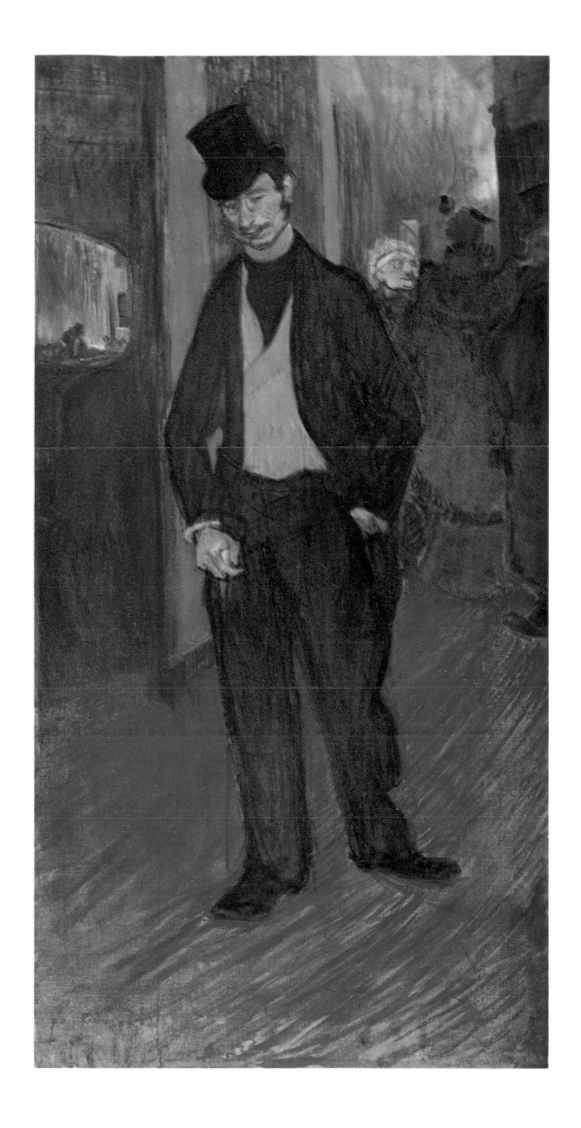

Dance at the Moulin Rouge

1890. Canvas, 115 x 150 cm. Collection Henry P. McIlhenny, Phildelphia

This elaborate composition shows how the dancers at the Moulin Rouge performed – not on a stage, but wherever they could clear a space for themselves amid the throng of patrons. It is not certain if the girl is La Goulue or not, but her partner is certainly the famous Valentin-le-Désossé. Valentin's real name was Jacques Reynaudin, and both his peculiarities of appearance and his extreme skill as the dancer helped to make him famous. He insisted on retaining his amateur status and worked without taking a fee. He had a small private income and worked in addition part-time for his brother who was a notary. During the day he was sometimes to be seen driving through the Bois de Boulogne in a smart phaeton, accompanied by La Goulue with whom, however, his relationship was purely platonic. He was perhaps the only man from whom the notoriously farouche La Goulue would take orders.

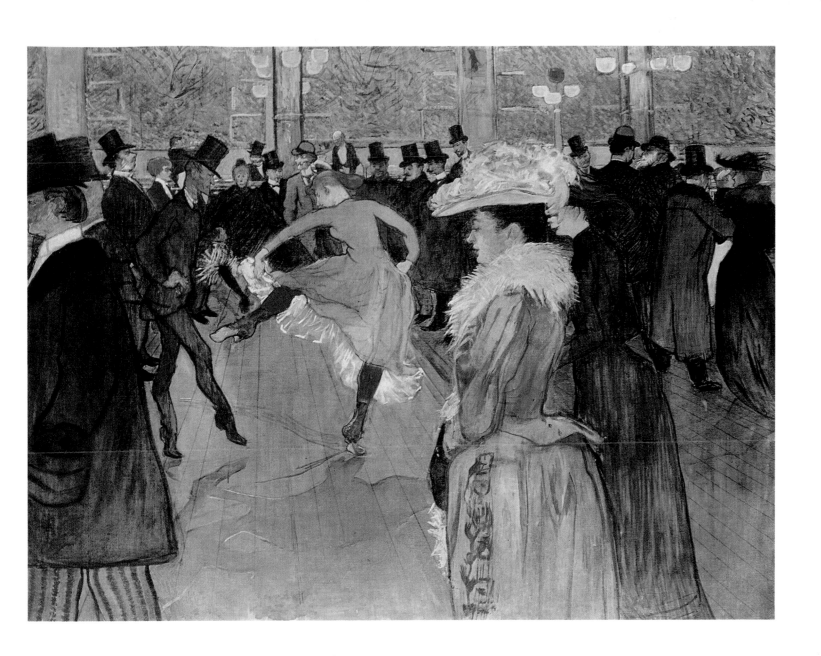

The Salon in the Rue des Moulins

1894. Pastel, 111.5 x 132.5 cm. Musée Toulouse-Lautrec, Albi

This is the culmination of the whole series of brothel scenes painted by Lautrec, and shows the girls waiting for clients in the 'Moroccan' salon of the sumptuous brothel in the Rue des Moulins. The figure in the foreground with her leg drawn up is generally said to be a portrait of Mireille, who was a favourite of Lautrec's. She would come to see him in his studio – in fact, they eventually made an arrangement that he would pay for her to take a day off on the occasions when he wanted her to come. However, there is an objection to this identification: it is also said that Lautrec deserted the brothel in the Rue d'Amboise, which he had previously frequented, for the newer and grander one in the Rue des Moulins, precisely because Mireille had left the former. Lautrec told a friend: 'Mireille's off to Argentina. Some meatpackers have convinced her she can make her fortune out there. I've tried to talk her out of it, but she really believes all their claptrap. None of the girls who go there ever come back. After two years of it, they're finished.'

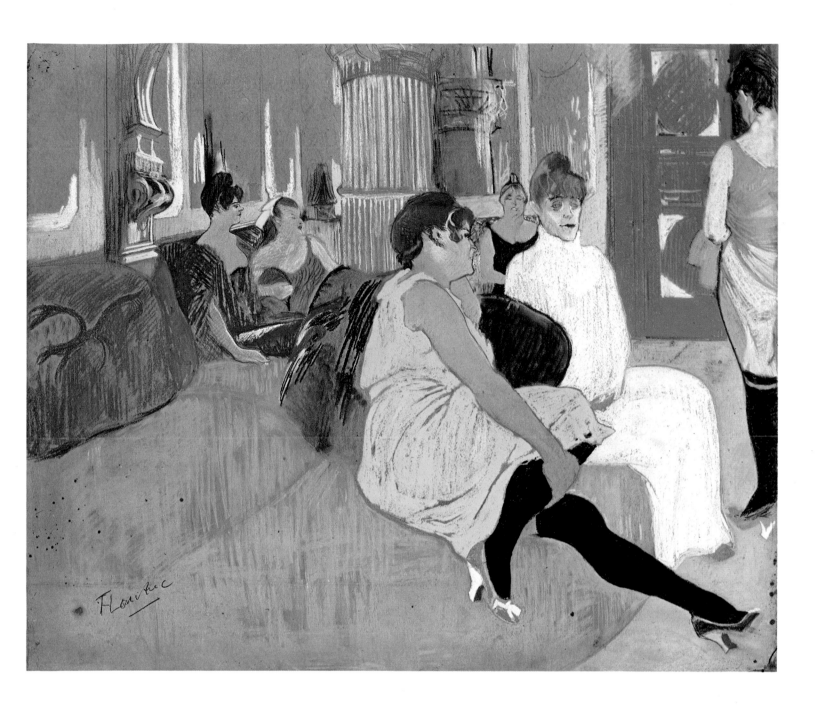

1893. Cardboard, 57 x 44 cm. Hahnloser collection, Berne

Fig. 22
**Woman with a Tray
(Juliette Baron and
Mlle Popo)**

1896. Lithograph
(from the 'Elles' album),
40 x 52 cm.

Another view of girls waiting in the Salon in the Rue des Moulins for clients to arrive. The relaxed, unselfconscious air of his subjects is a tribute to Lautrec's own special position in the house – he had the complete run of it at all hours, as the lithograph *Woman with a Tray* (Fig. 22) suggests. 'Among these women,' one witness wrote, 'Lautrec is like a spoilt child, amiably tyrannizing them. They appreciate his friendly simplicity, which never trades on the fact that he is not only a famous artist, but bears a most illustrious family name.' Lautrec is described as wandering about, thumping the ground with his cane and sometimes loudly singing patriotic songs. He would take time to gossip with the girls about their love affairs and the men they kept, and took a keen interest in the most minor details of their lives. He did, however, profess to be shocked by a wedding card sent out for one of them, issued collectively by 'the ladies of the Rue des Moulins'.

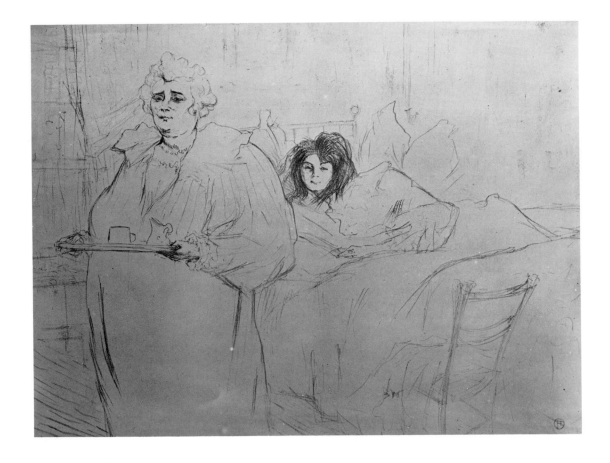

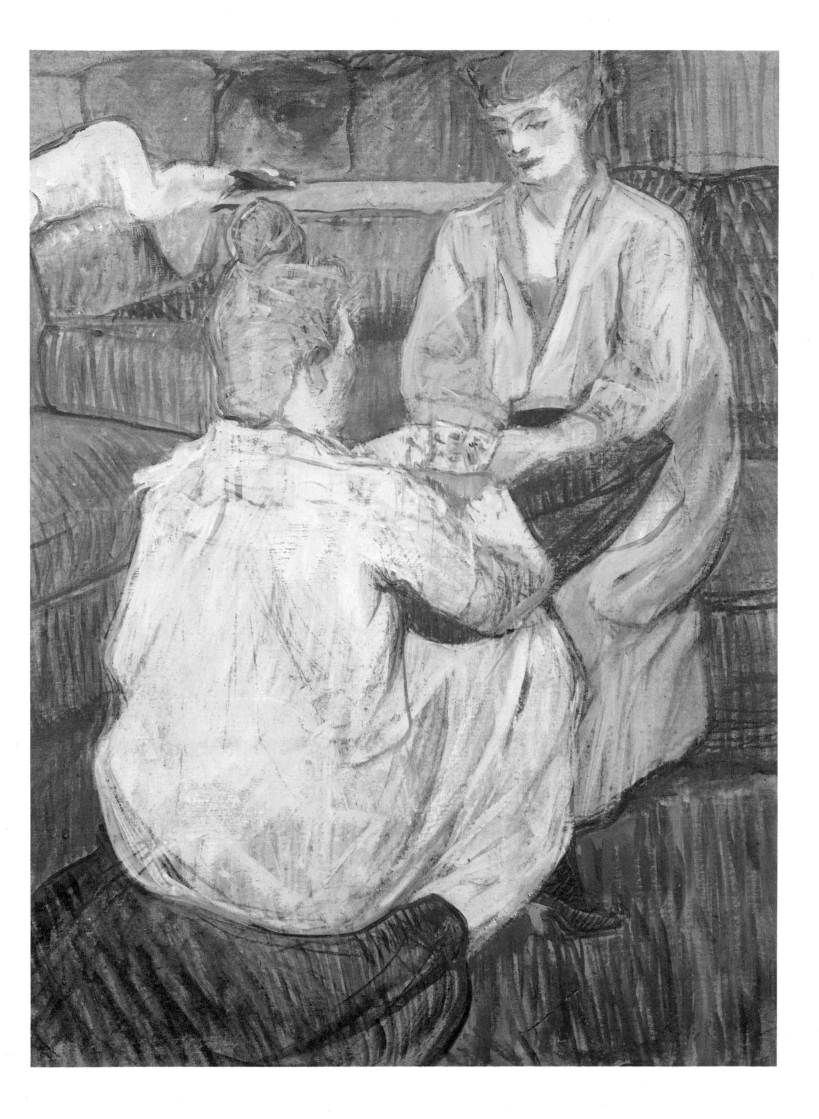

Les Deux Amies

c.1894. Cardboard, 48 x 34 cm. The Tate Gallery, London

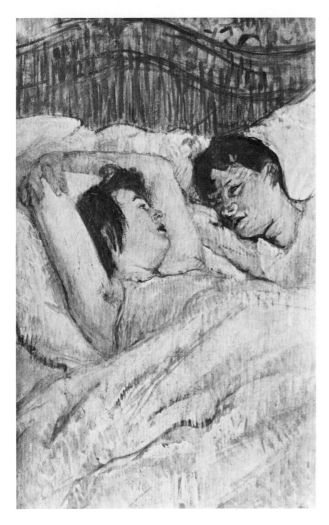

The life led by the girls in the brothel often sparked lesbian relationships between them. They found in these some of the tenderness and compassion they were denied by the men who bought their professional services. Lautrec was attracted by this phenomenon, and lesbianism is a particular theme of the whole series of brothel paintings. The girls were shown caressing one another, or tucked up in bed together (Fig. 23). Lautrec collected snapshots and other mementoes which documented life in *les maisons closes*. One photograph was a source of special fascination to him – it showed two of the girls curled up together. He showed it to his friend the engraver Charles Mauring with the enthusiastic comment: 'That beats everything. Nothing can match something as simple as that.' But it is difficult to make out whether his own reactions were in fact quite as straightforward as this suggests. Male voyeurs have always been drawn by lesbian activities, for reasons which contemporary psychologists are eager to explain.

Fig. 23
In Bed

c.1893. Oil on cardboard,
53 x 34 cm.
Foundation E.G. Bührle
collection, Zürich

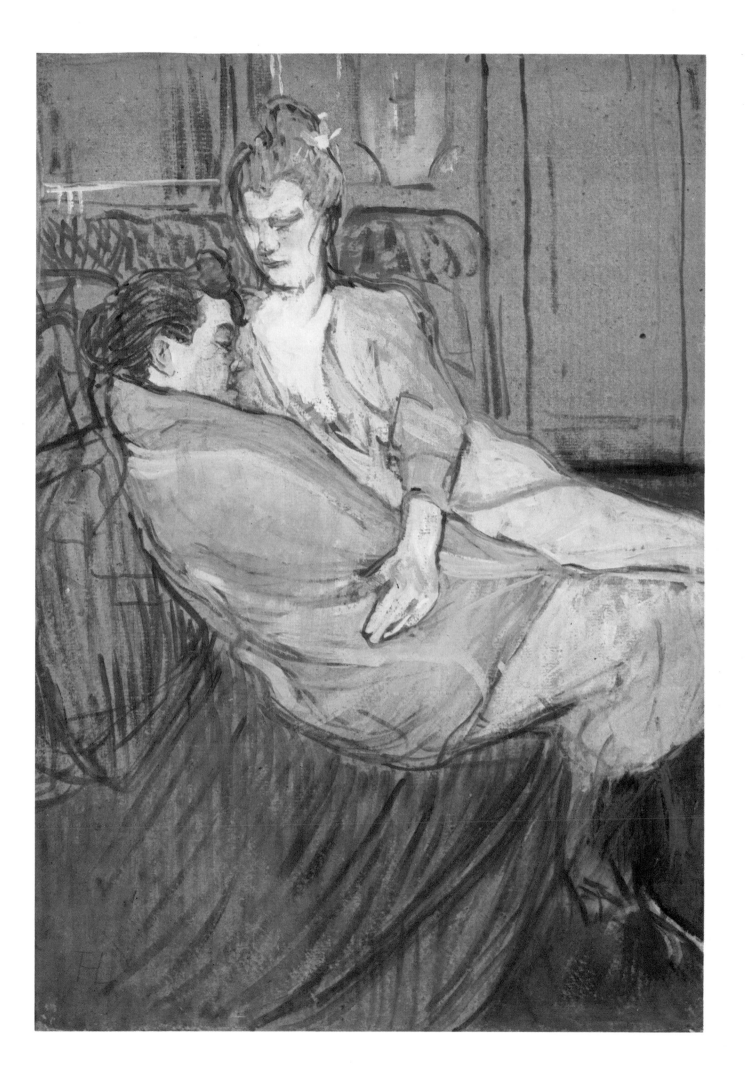

1894. Cardboard, 58 x 46 cm. Musée d'Orsay, Paris

Fig. 24
Sleeping Woman

c.1896. Red chalk on
paper, 20 x 27 cm.
Museum Boymans-Van
Beuningen, Rotterdam

The brothels Toulouse-Lautrec frequented offered him a wide variety of subject matter, including many opportunities to draw the female nude. *Woman Adjusting her Garter* is one of the boldest and most masterly of these nudes, but also one of the most defiantly sexual in its implications. The nude girl is evidently a prostitute watched by a rather hatchet-faced brothel maid. The combination of dress and undress is extremely provocative – far more so than if the figure were entirely unclad. What is particularly impressive about the picture is the way in which Lautrec renders a body which is by no means ideally beautiful – in parts sagging, in others lumpy. The emphasis on volume is somewhat unusual for him – the *Sleeping Woman* (Fig. 24), with its economical use of countour, is far more typical of his usual methods, and also more traditional in its effect – it descends from the nudes of Ingres and even from those of Boucher and Watteau.

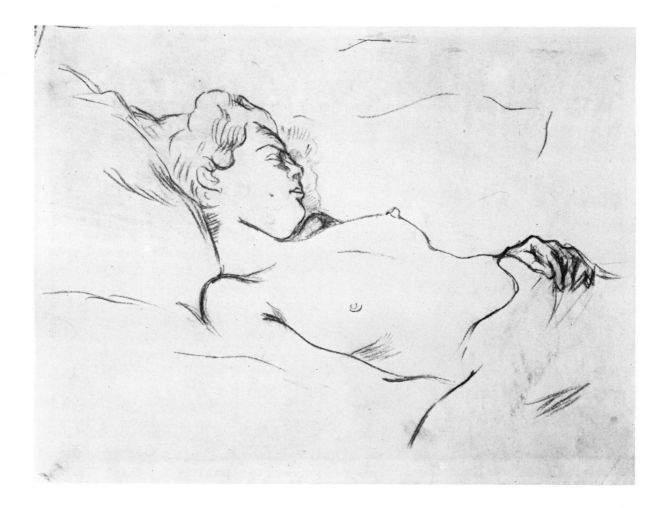

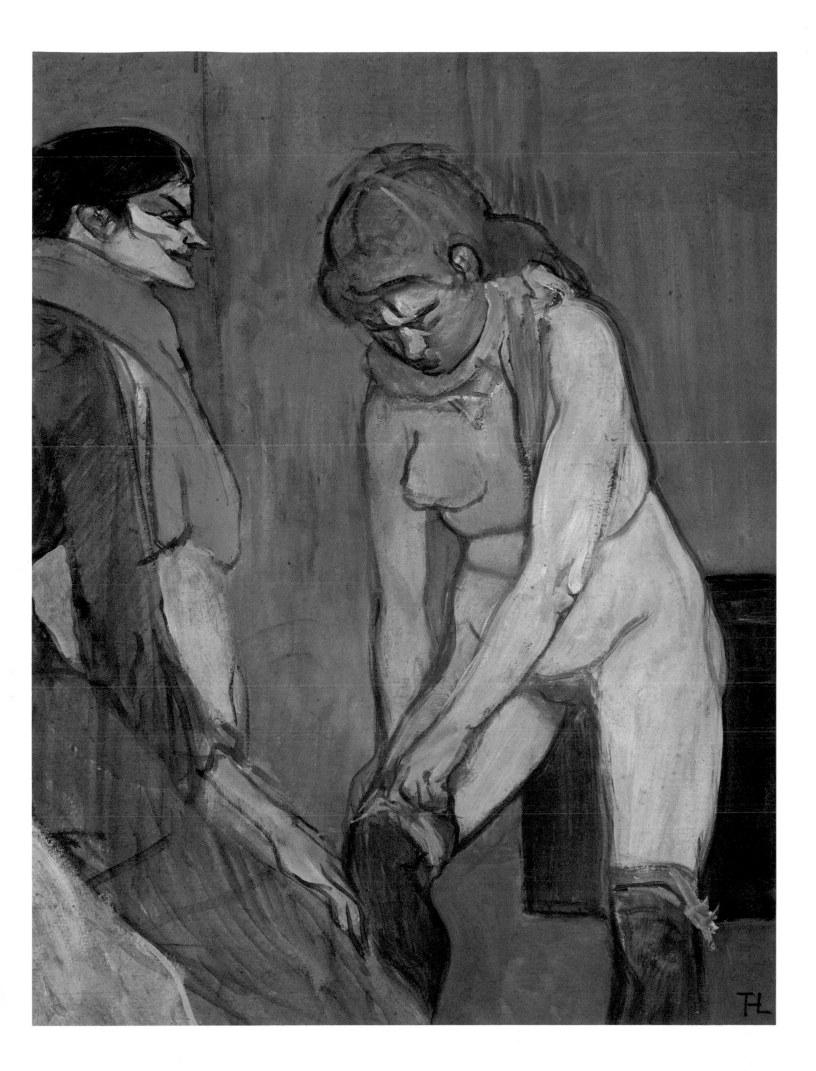

Loïe Fuller

1893. Poster (lithograph coloured by hand), 43 x 27 cm. Bibliothèque Nationale, Paris

Representations of the American dancer Loïe Fuller are among the most abstract of all Lautrec's music-hall subjects. For once he concentrates on the general effect rather than on the personality of the performer. Loïe Fuller did a solo turn at the Folies-Bergère which attracted artists and intellectuals as well as the usual music-hall habitués. The spectacle she devised had a considerable influence on Art Nouveau design. Innumerable small sculptures, and candlesticks and table-lamps in gilt or silvered bronze, survive to commemorate the impact she made. Her 'turn' was a kind of precursor to some of the spectacles presented a little later by Diaghilev. The stage was lit by electric spotlights, shining through panes of coloured glass set in the floor, and Fuller wore immense filmy draperies which she manipulated with long rods so that her figure was almost lost from view. Lautrec devised special ways of rendering the fleeting effects she created, splattering his prints with colour from the bristles of a toothbrush, and sprinkling them with gold dust. There is one print of Jane Avril (Fig. 25) where her appearance is treated in a similar way.

Fig. 25
Jane Avril

1893. Lithograph,
26.5 x 21 cm. From the
album 'Le Café-Concert'

Aristide Bruant

1893. Poster (coloured lithograph), 127 x 92.5 cm.

Fig. 26
Aristide Bruant

1893. Lithograph,
26.5 x 21 cm. From the
album 'Le Café-Concert'

Aristide Bruant made his impact on Montmartre somewhat earlier than Lautrec himself. A railroad employee who wrote songs in his spare time, he turned professional at the age of thirty-four and in 1885 founded a little cabaret called the Mirliton. For his appearances he devised a special costume – floppy hat, cape, black velvet suit, red scarf and short boots. His songs were rough and rustic, and he greeted the bourgeois public who flocked to see him with a hail of insults. He was one of Lautrec's early favourites, and Bruant reciprocated this admiration by allowing the young artist to decorate the Mirliton with some pictures. Later Lautrec did the famous poster design for him which is reproduced here. Unlike Yvette Guilbert, Bruant did not underestimate the value of such an image to his career, and firmly forced a reluctant manager to display it when he moved to a new and grander venue, threatening not to appear unless it was shown. It catches the force of Bruant's character, but his coarse and sardonic side is perhaps better rendered by the three-quarter-face portrait also reproduced here.

THÉATRE ROYAL
DES
Galeries Saint-Hubert
SAMEDI 8 JUILLET

aristide
Bruant
dans son cabaret

1895. Watercolour, 58.5 x 48 cm. Private collection

Fig. 27
Oscar Wilde and
Romain Coolus

1896. Lithograph,
30 x 49 cm.

Lautrec paid frequent brief visits to London, and one of these took place early in 1895, just at the time when the first of Wilde's two trials was taking place – properly speaking not a trial at all, since Wilde was the plaintiff in a libel action against the Marquis of Queensberry. Lautrec was fascinated by Wilde's appearance, and wanted to make a portrait. Wilde refused to sit, but languidly allowed the artist to 'look at him' once or twice. The striking image reproduced here in colour was the result. It shows Wilde as a figure simultaneously decadent and heroic, posed against the symbolic background of the Thames and the Houses of Parliament. No attempt is made to flatter the subject's actual appearance, but his features, even the rosebud mouth, are infused with a certain sad nobility, in a way which is unusual for Lautrec. Wilde's fate aroused a good deal of attention, and also sympathy, on the other side of the Channel; the picture was reproduced in *La Revue Blanche*, and also served as a basis for a programme decoration for Lugne-Poe's Théâtre de l'Oeuvre (Fig. 27) when the latter paired a production of Wilde's *Salome* with one of a play called *Raphael* by Lautrec's close friend, Romain Coolus.

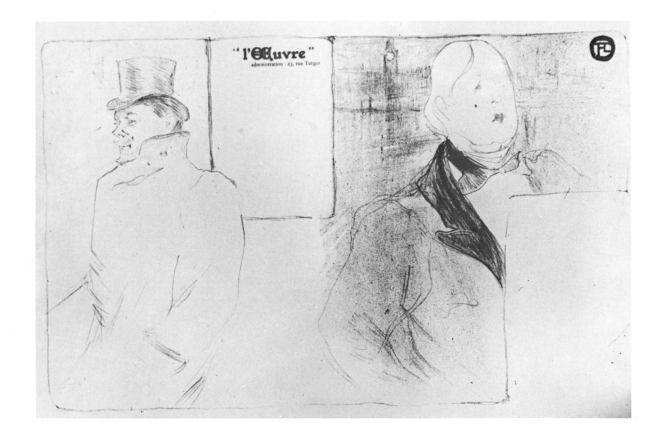

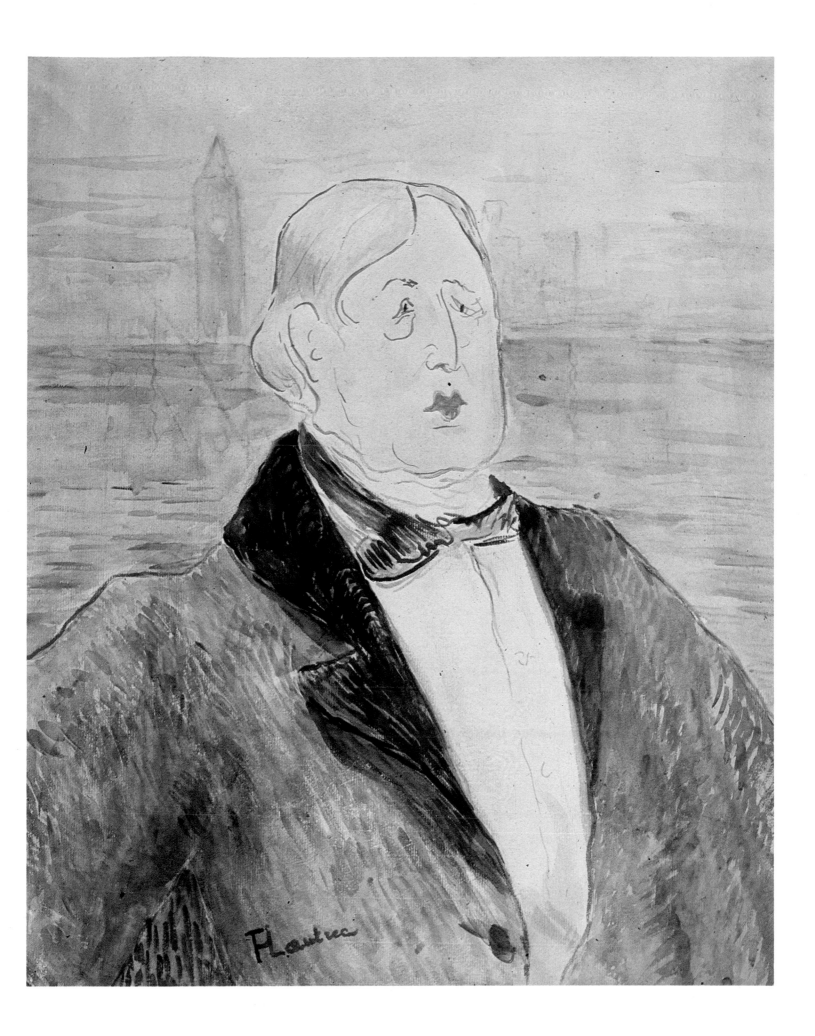

1895. Canvas, 298 x 316 cm. Musée d'Orsay, Paris

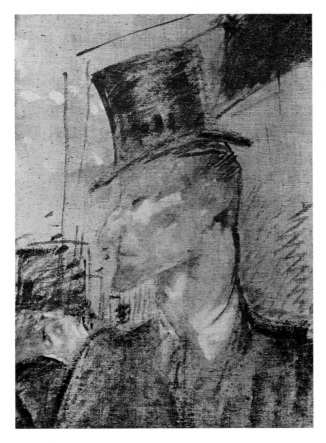

This large painting and its companion have a genesis which would be unexpected in any artist other than Toulouse-Lautrec. In 1895 La Goulue, after three years of success at the Moulin Rouge, decided to leave and put on a show of her own at the fairground called the Foire du Trône. On 7 April she wrote to Lautrec asking him to paint something for her booth there 'on the left as you come in'. It was just the kind of commission (except it is highly unlikely that any money changed hands) to tickle Lautrec's sense of humour. Clearly the work had to be done very rapidly, and these large canvases are treated in a deliberately sketchy way, not only for this reason but because the decoration had to carry and to be seen at a distance. In this canvas Lautrec tried to sum up everything he had learned at the Moulin Rouge – the aim was to call vividly to mind the environment in which La Goulue had made her reputation. Many of the details are of staggering boldness – for example the monumental head of Valentin which is a focal point in the left-hand composition.

Fig. 28
Detail of Plate 31,
showing Valentin-
Le-Désossé

1895. Canvas,
298 x 316 cm.
Musée d'Orsay, Paris

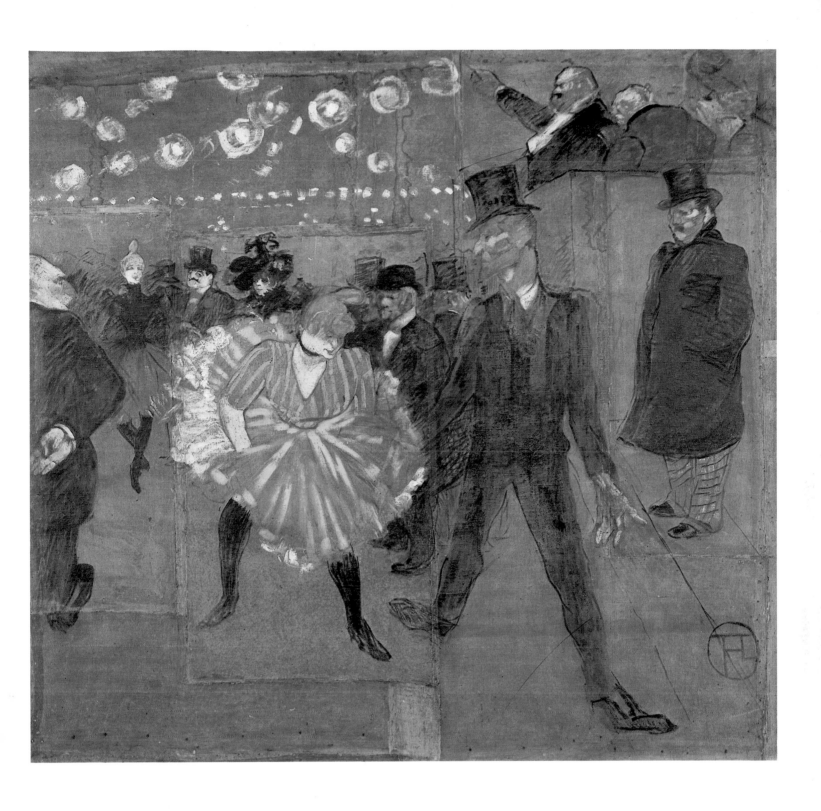

Detail of Plate 31, showing La Goulue

1895. Canvas, 298 x 316 cm. Musée d'Orsay, Paris

Toulouse-Lautrec demonstrates his ability to create convincing forms by the simplest and most minimal of means in this representation of La Goulue from the first of the two pictures he did for her booth at the Foire du Trône. The ground shows through at almost every point – it is used to create the ruffles in her skirt and the vertical stripes in her blouse. She is shown wearing her trademark coiffure (hair screwed into a knot on top of her head), and her usual ribbon round the neck. Her fringe almost covers her forehead, and the upper part of her face is masked with a pinkish patch of shadow. Lautrec's sense of her individuality is conveyed not through his observation of her face and expression but by the way he depicts her body – the slightly awkward straddling pose, the broad shoulders, the arms which press down her rebellious skirt. She is portrayed as the incarnation of stubborn animal vitality, almost as if she were a bullock about to butt her partner in the midriff.

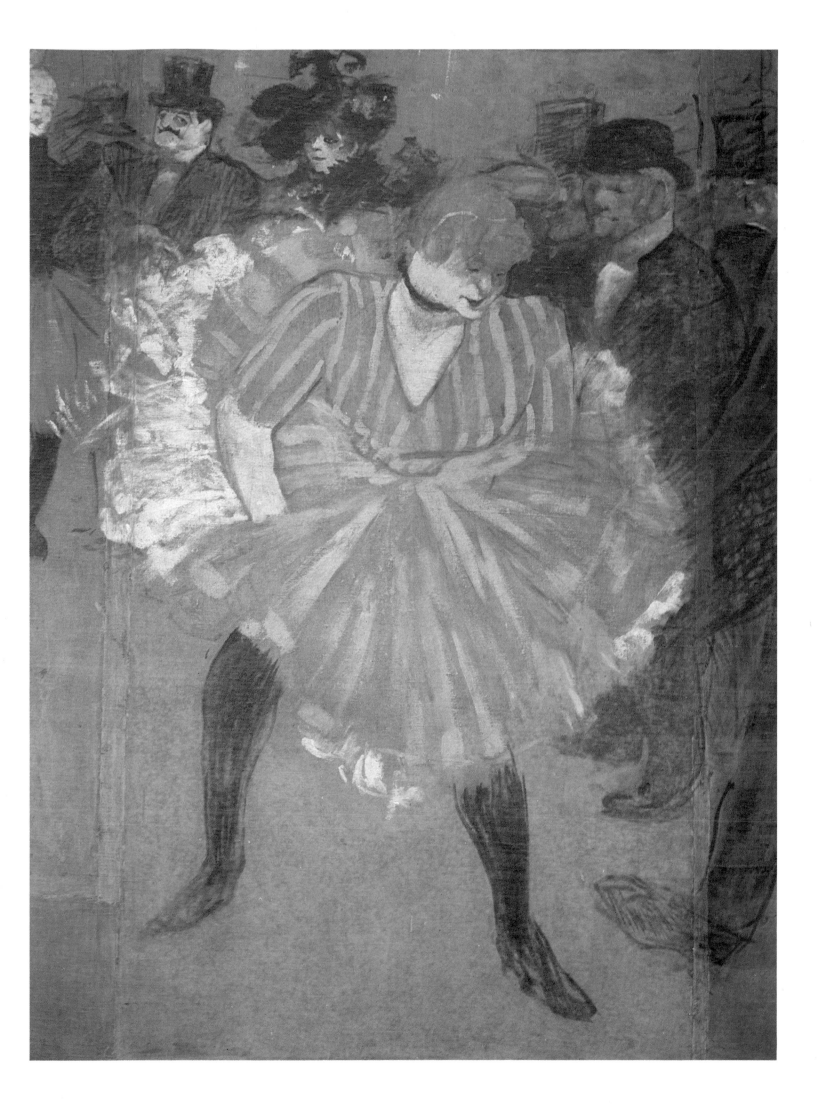

La Goulue Dancing ('Les Almées')

1895. Canvas, 285 x 307.5 cm. Musée d'Orsay, Paris

This is the second of the two paintings produced by Lautrec for La Goulue's fairground booth. It shows her performing a supposedly oriental dance – an *almée* is an eastern dancing girl – and represents the kind of entertainment she intended to offer in the booth itself. Obviously there was nothing very authentic about the performance, as she is shown doing the high kick which typified the not-at-all-oriental can-can. A pair of eastern musicians can, however, be seen to the right, one apparently beating a small drum with the palm of his hand, the other shaking a tambourine. Press reports also tell us that La Goulue offered a group of belly dancers to back her own efforts. On the whole these were badly received, though the booth itself received considerable journalistic coverage. Cormon, with whom Lautrec had studied, was persuaded to go and see it, but returned muttering peevishly: 'So that is what is called a masterpiece!'

La Goulue's own subsequent career was tragic. She tried different branches of show-business, having become too fat and ungainly to dance, and worked at one time as an animal-tamer. She finally ended up as a miad in a brothel, and died destitute in 1929.

The canvases Lautrec painted for her were cut into more saleable portions by a picture-dealer in 1926, but survived to be pieced together once more, though the marks of this vandalism remain visible.

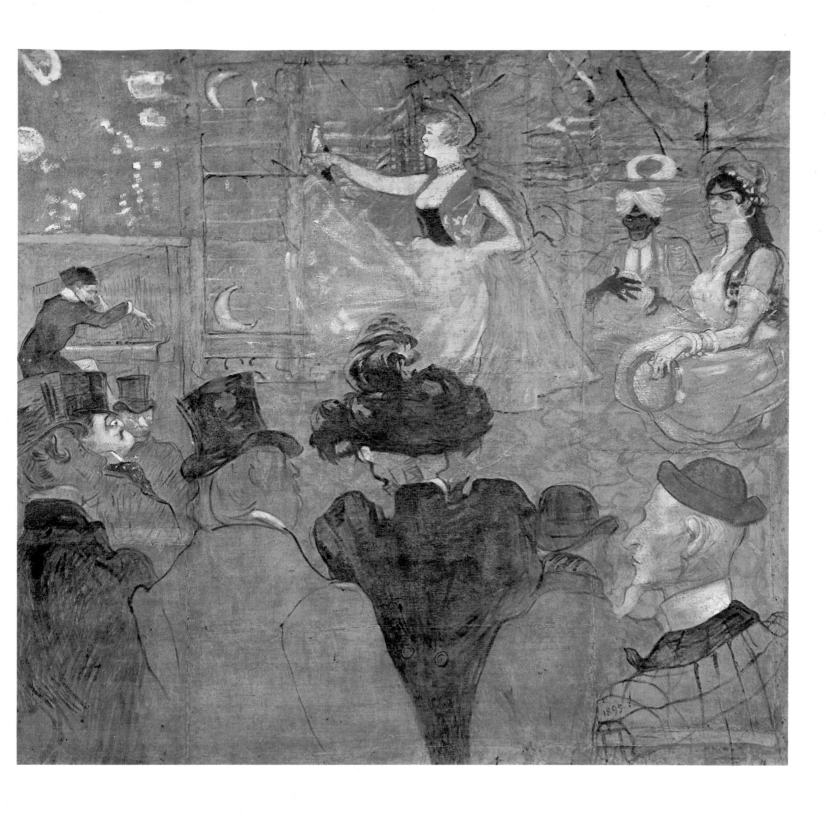

Detail of Plate 33, showing Oscar Wilde

1895. Canvas, 285 x 307.5 cm. Musée d'Orsay, Paris

Lautrec's use of a personal mythology based on friendship is well illustrated in this detail from the second canvas done to decorate La Goulue's fairground booth. All the people shown can be identified. From left to right they are Tinchant, pianist at the Chat Noir, one of the cabarets Lautrec frequented, the photographer Sescau, Maurice Guibert, Dr Gabriel Tapié de Céleyran, Oscar Wilde and (not shown in this plate) Jane Avril, Lautrec himself, and the art-critic Felix Fénéon. Wilde's presence is purely symbolic. He had probably never seen La Goulue in her days of glory at the Moulin Rouge, and his presence here is a covert allusion to the fact that, like Wilde, though in a different fashion, she had now fallen on hard times. Fénéon was included for a similar reason – once a civil servant, he had been jailed for his support of anarchism and dismissed from his post, and now had a job on *La Revue Blanche*. The portraits themselves are of reckless brilliance – on the very borders of caricature. They demonstrate not only the extraordinary fluency of Lautrec's draughtsmanship, but his total indifference to established pictorial convention.

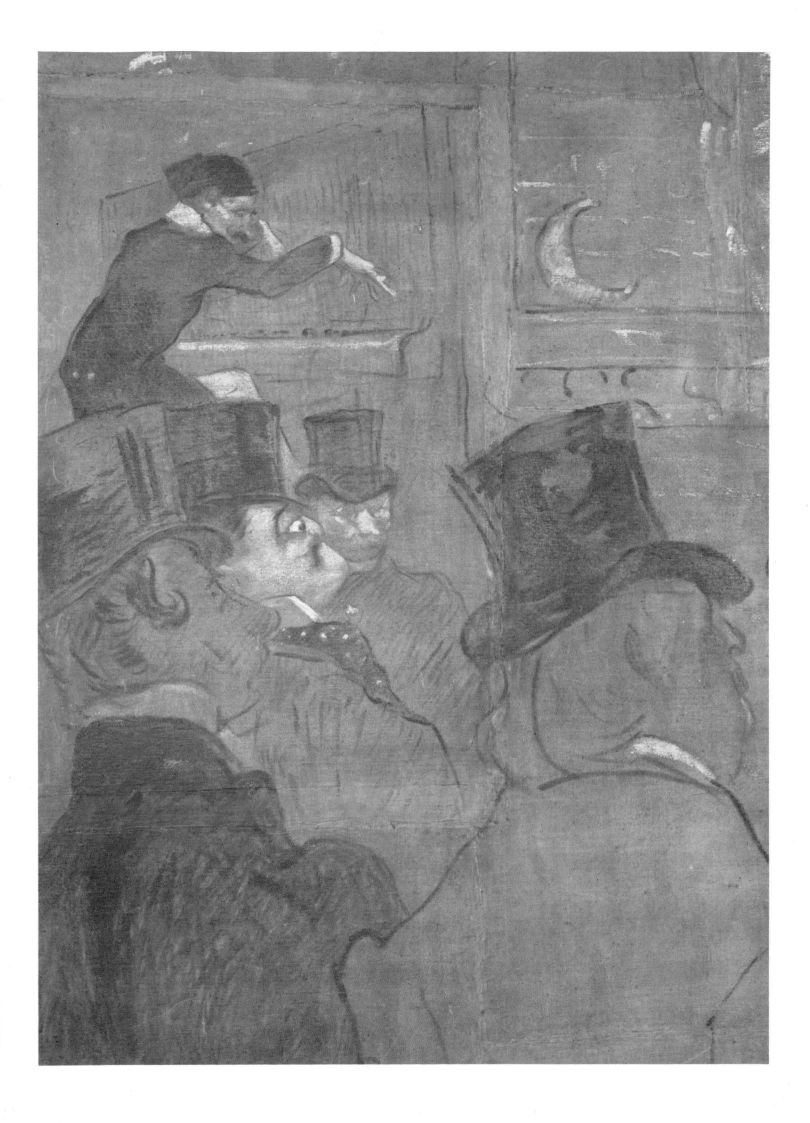

The Clowness Cha-U-Ka-O

1895. Cardboard, 64 x 49 cm. Musée d'Orsay, Paris

This is a backstage portrait of someone who seems to have fascinated Lautrec at least as much as La Goulue and Jane Avril. The clowness claimed to be Japanese, but her name was in fact based on a complicated French pun – on the words *chahut* – the high kick which featured in the can-can – and *chaos*. The painting is a remarkable example of Lautrec's ability to establish character and resemblance by completely unconventional means. The woman seems quite unaware of the painter's presence, and is absorbed in the task of adjusting her costume. Half her face is hidden by the raised shoulder nearest to us, yet she remains completely recognizable. Another feature of the painting, not commonly found in Lautrec, is its feeling for volume. The rapid strokes of the brush mould the subject's massive shoulders and bust in an entirely convincing way.

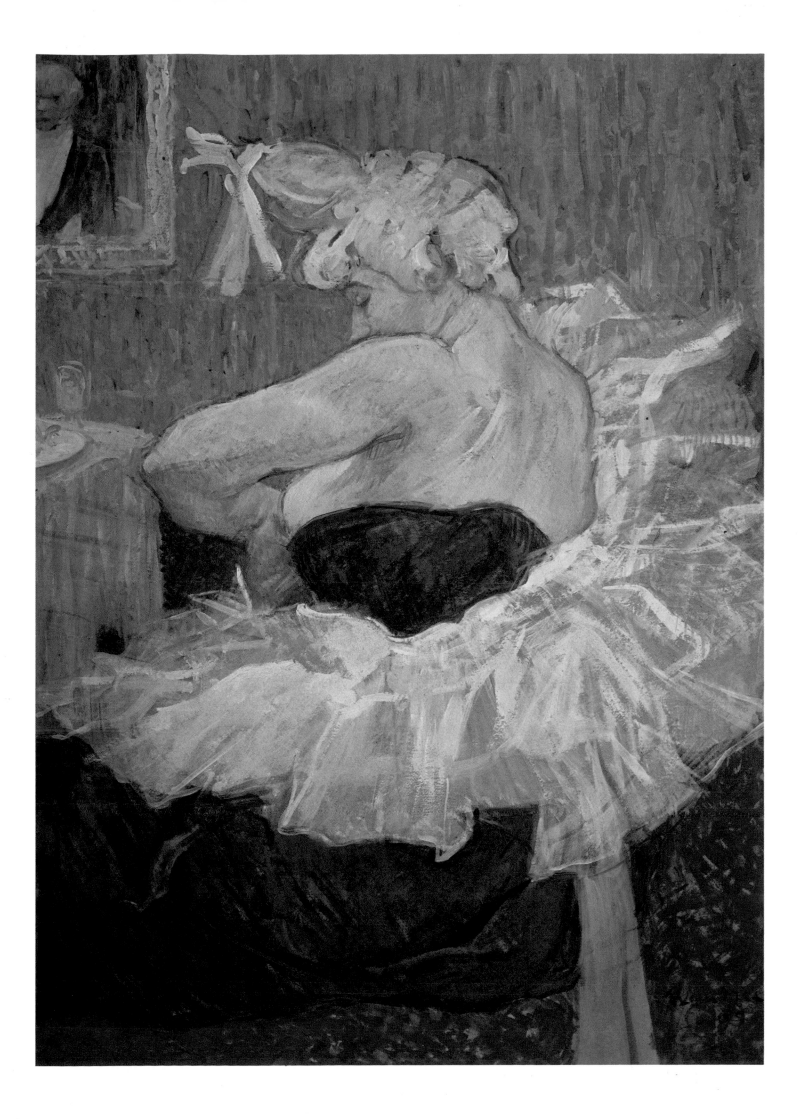

1896. Cardboard, 60 x 80 cm. Musée d'Orsay, Paris

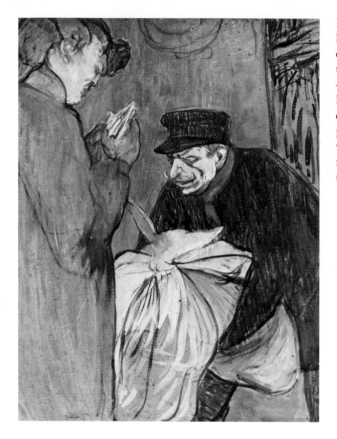

Fig. 29
The Brothel
Laundryman

1894. Oil on cardboard,
58 x 46 cm. Musée
Toulouse-Lautrec, Albi

Lautrec was interested in the brothel, not so much as a place of sexual licence but as a special kind of closed community – the next best thing to a convent. The relaxed, confidential poses of the women seated round a table convey that for them this is an ordinary and accustomed environment – so ordinary that it generates a certain lethargy and boredom. The leering laundryman (Fig. 29), on the contrary, is an intruder, a necessary outsider, come to remove the soiled sheets which were among the brothel's waste products. Here Lautrec accurately captures the feeling that the *maison close* was a distinctly unromantic place of drudgery. It is the keen sense of social relationship which firmly removes the brothel paintings from any suggestion of pornography.

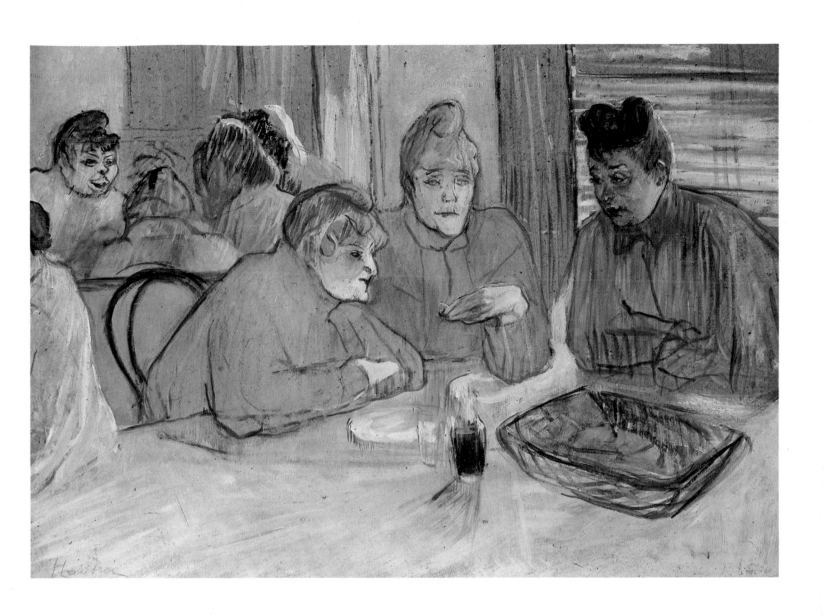

Woman at her Toilet

1896. Cardboard, 67 x 54 cm. Musée d'Orsay, Paris

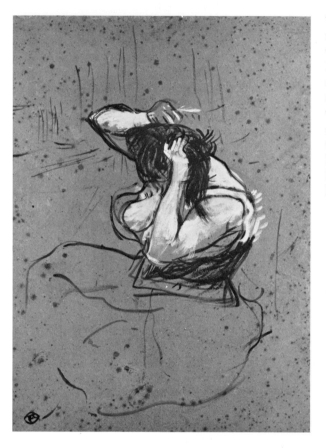

Fig. 30
**Woman Combing
her Hair**

1896. Oil on cardboard,
55 x 41 cm. Musée
Toulouse-Lautrec, Albi

This, too, is probably a scene in a brothel, but here Lautrec reverts very firmly to the influence of his master, Degas. The overriding comparison which immediately suggests itself is to the long series of compositions by Degas – they include pastels, sculptures, etchings and monotypes – showing women washing themselves. At least one Degas monotype of this subject, of c.1879, has a brothel for its setting, and belongs to the series which also contains *The Serious Client* and *The Madame's Birthday*. Degas almost invariably chooses a high viewpoint, often with the girl's back turned towards the spectator, and that is precisely what Lautrec does here. He even allows himself a real suggestion of depth – usually by this time banished from his work. It is one of his most heartfelt tributes to the master he adored.

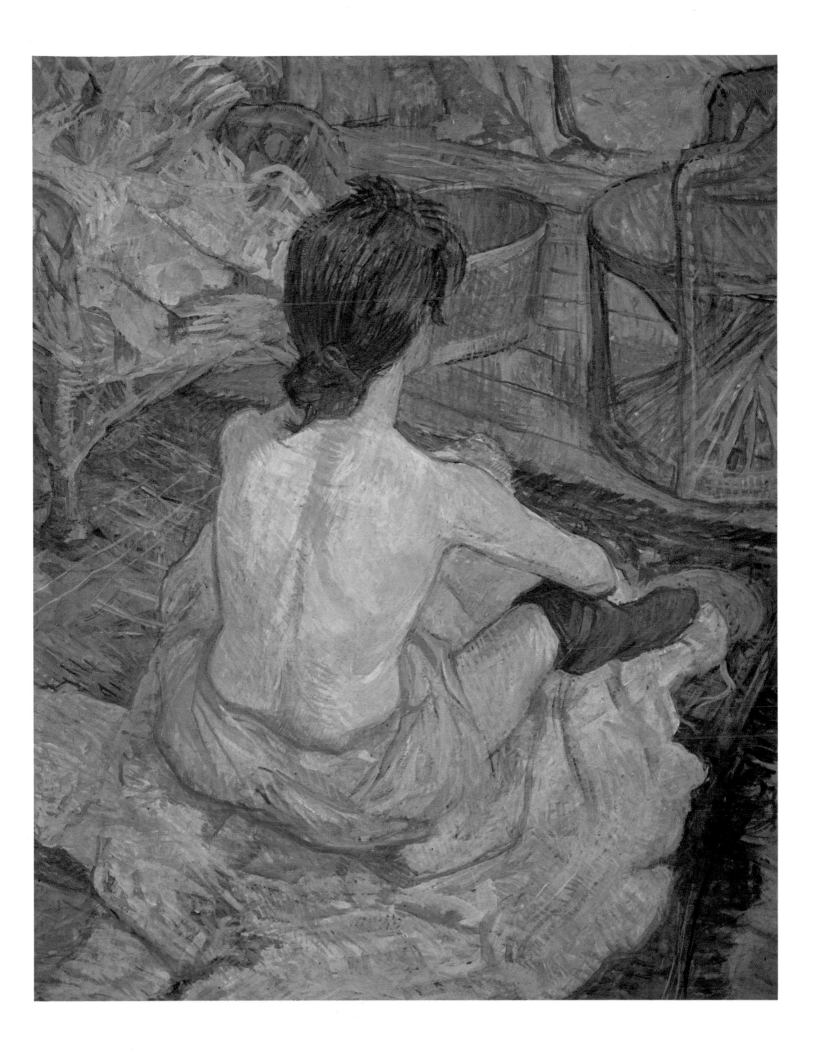

Marcelle Lender, Standing

1896. Coloured lithograph, 35 x 24 cm.

Fig. 31
Marcelle Lender
and Albert
Brasseur in
'Madame Satan'

1893. Lithograph,
34 x 25 cm.

The actress Marcelle Lender was a comparatively late enthusiasm of Lautrec's. She belonged to the legitimate theatre, not the cabaret or music-hall. She differed from most of the other female performers he liked by being genuinely very attractive. She was celebrated for her elegance as well as for her talent. One thing about her which would certainly have attracted Lautrec was her red hair – he had a marked taste for red-haired women. He began by making a few sketches and a lithograph of her in 'straight' roles (Fig. 31), but it was not until 1896 that his enthusiasm burst into full flame. It was in this year that she took the female lead in Hervé's operetta 'Chilpéric' at the Variétés (see Plate 41 and Fig. 33). Lautrec reserved the same seat in the theatre night after night – just to the left of the centre gangway in the stalls – and would arrive in time to see her do her star turn, dancing the bolero. He made all his friends accompany him, and when one of them protested that he had heard the music often enough, Lautrec declared: 'I simply come to see Lender's back. Take a good look at it, you've never seen anything so magnificent.'

1895. Cardboard, 81 x 60 cm. Mrs Florence Gould collection, New York

Fig. 32
Carnival at the
Moulin Rouge:
entry of
Cha-U-Ka-O

1896. Blue crayon,
63 x 50 cm.
Fogg Art Museum,
Cambridge, Mass.

Cha-U-Ka-O often seems one of the most enigmatic of Lautrec's people – no source gives much information about her. She certainly looks enigmatic here. With hands thrust deep in the pockets of her costume, she is entirely solitary and introspective. Her sphinx-like quality is emphasized by the fact that her eyes are slightly crossed, so that she seems to be gazing inward towards the tip of her own nose. In his splendid drawing (Fig. 32), showing Cha-U-Ka-O at the head of a Mardi-Gras procession in the Moulin Rouge, Lautrec preserves her withdrawn and hieratic air.

The artist is said to have been fascinated by the total spontaneousness and unpredictability of the working-class girls with whom he came into contact in the cabarets and brothels of Montmartre. But his interest in this female clown went somewhat further. One aspect of her fascination for him was clearly her lesbianism. This was not merely a product of circumstances, like that of the women he knew in the Rue d'Amboise and the Rue des Moulins, but an important part of a somewhat aggressive personality.

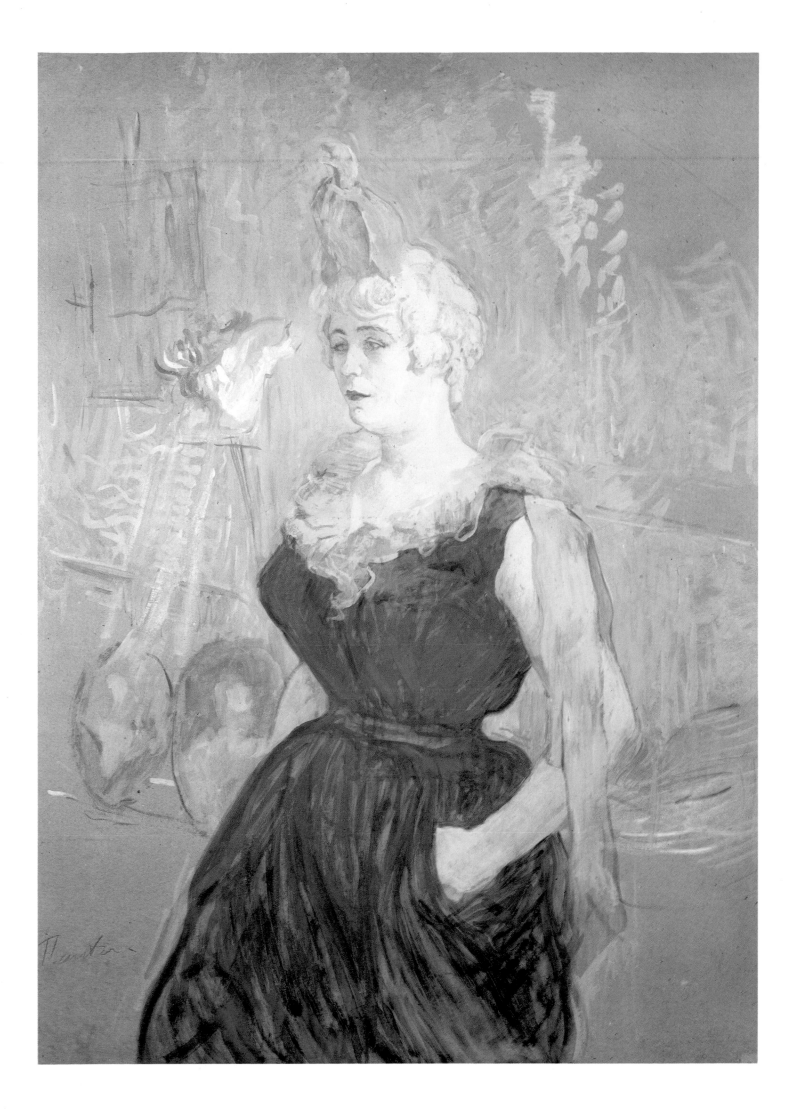

Paul Leclercq

1897. Cardboard, 54 x 67 cm. Musée d'Orsay, Paris

Leclercq was a writer who belonged to the *Revue Blanche* circle. He left some reminiscences of Lautrec which were published in *La Grande Revue* in 1920, and gave this portrait of himself to the Louvre in the following year. The painting was done just after Lautrec had moved his studio from Rue Caulaincourt, where he had been for ten years, to 15 Avenue Frochot, perhaps in order to be nearer his mother, with whom he lunched every day. Leclercq recalled that when he first climbed the two flights of stairs, he heard a sound like someone rolling bread with a rolling pin. It turned out to be Lautrec in a red flannel shirt and a yachting cap, busy with a rowing machine. Leclercq sat three or four times a week for a month, but the estimated total sitting time was only three or four hours. Lautrec would pick up the brush, make three or four strokes, working his thick lips meanwhile as though tasting something delicious, and would then insist they both adjourned to the nearest bar.

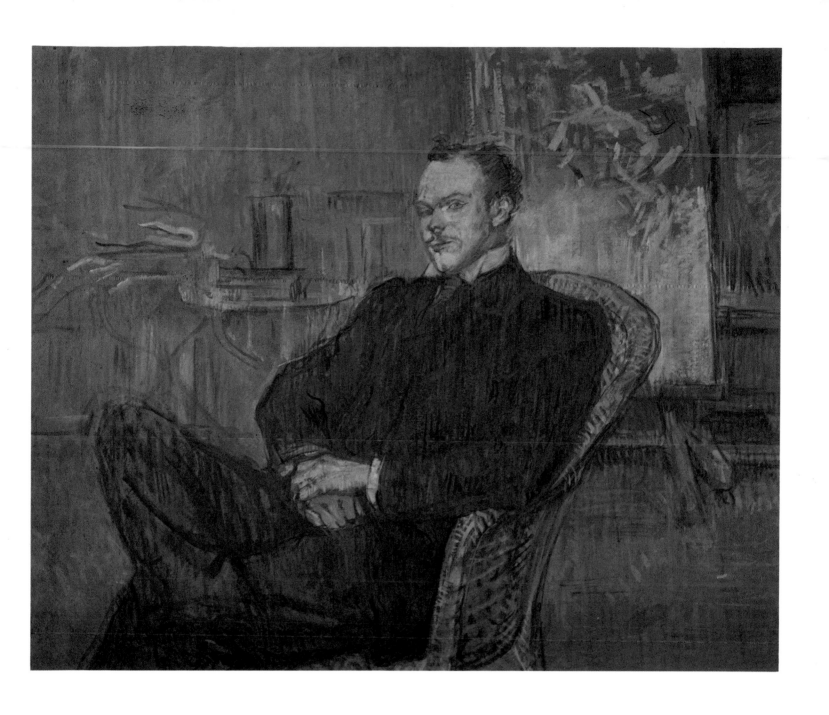

Marcelle Lender Dancing the Bolero in 'Chilpéric'

1895. Canvas, 45 x 150 cm. John H. Whitney collection, New York

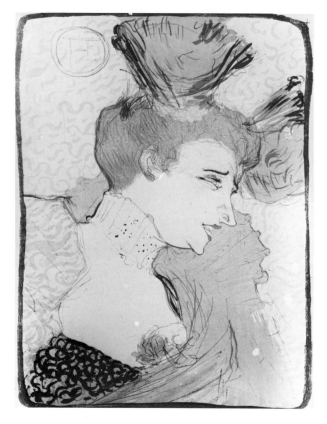

Fig. 33
The Actress
Marcelle Lender
(in the Théâtre
des Variétés 1895
production of
Hervé's operetta
'Chilpéric')

1895. Coloured lithograph,
32.5 x 24 cm.

This is perhaps the best, as well as the most elaborate, of Lautrec's theatrical scenes, and shows Lender doing her famous dance. One of its major virtues is the brilliance of its colour – not always a strong point with Lautrec. Those of his contemporaries who liked his work frequently complained of his weakness in this respect. He is also particularly successful in conveying the movement of the dance, and its theatrical atmosphere. The figures surrounding Lender pose with a sharply observed artificiality which conveys the full atmosphere of the piece in its essential absurdity.

Though Lautrec was always singing various popular songs, both in season and out, it is clear he had no real taste for music – in this he lacked the refinement and cultivation of his master, Degas. What fascinated him about the theatre was something intangible, the sense of occasion which the performers generated night after night. Here he was supremely successful in rendering what interested him.

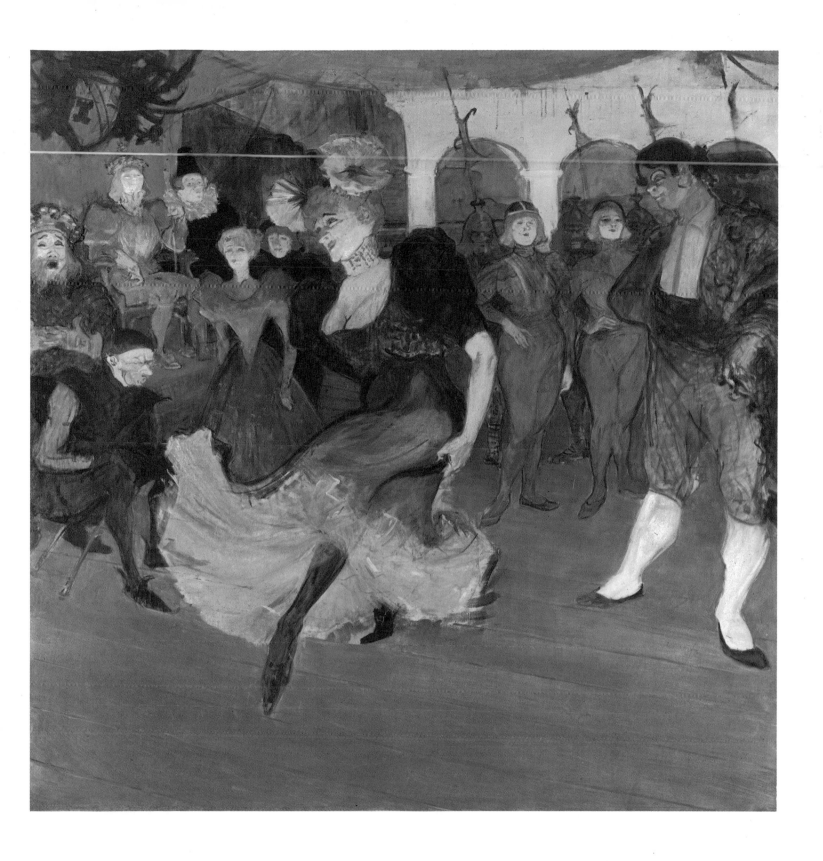

42 In the Bar

1898. Cardboard, 81.5 x 60 cm. Kunsthaus, Zürich

Lautrec, like Degas, was often fascinated not by reactions between individuals, but by their frequent indifference to each other. This painting is related in subject matter to *A la Mie* (Plate 8), but is later and considerably subtler. It shows a plethoric customer in a bar, with, behind him to the right, a pale cashier. Both individuals are lost in their own thoughts – if the man can actually be said to be thinking at all as he gazes blearily into the distance. The picture is based on what Lautrec observed in one of the bars around the Opera and the Madeleine which he frequented at the time when it was painted. He liked 'Weber's', the 'Irish and American', the 'Picton' in the Rue Scribe, and 'Achille's' a few doors away. The 'Irish and American', in the Rue Royale, was probably the most English of all the bars in Paris, visited by English jockeys and coachmen, as well as English actors and writers, with a barman called Ralph who was half Chinese and half Red Indian. It was famous for its 'silent drunks sitting opposite the barman lost in contemplation of the rows of bottles'.

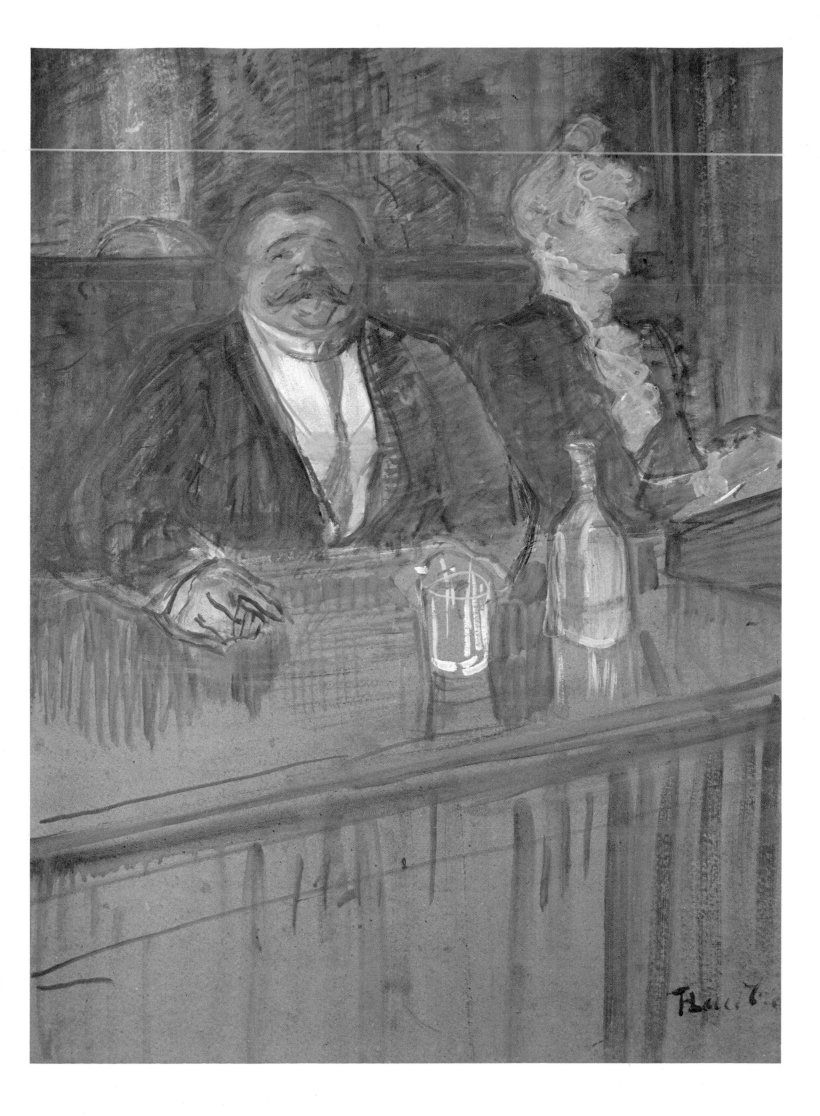

43 The Sphinx

1898. Cardboard, 81.5 x 65 cm. Alfred Haussmann collection, Zürich

This is the portrait of one of the prostitutes from the Rue des Moulins, generally held to be the most famous brothel in Paris. It is unlike earlier portraits of the inhabitants both of this and of another brothel Lautrec frequented in the Rue d'Amboise not only because the woman is considerably more attractive but because she has a sharply focussed air of aggressiveness, rather like the portraits of Cha-U-Ka-O. Though Lautrec was the spoilt child of the establishment, his relationship with the girls there was not always idyllic, especially at this period when he was deteriorating fast. It was not merely that he had to pay – like the rest of their clients – for sexual services, but also that they got a commission on whatever quantity he drank. They therefore actively encouraged his alcoholism, pushing him into a cab dead drunk in the early hours of the morning after he had spent the night in their establishment. This picture shows that Lautrec did not sentimentalize his companions in any way.

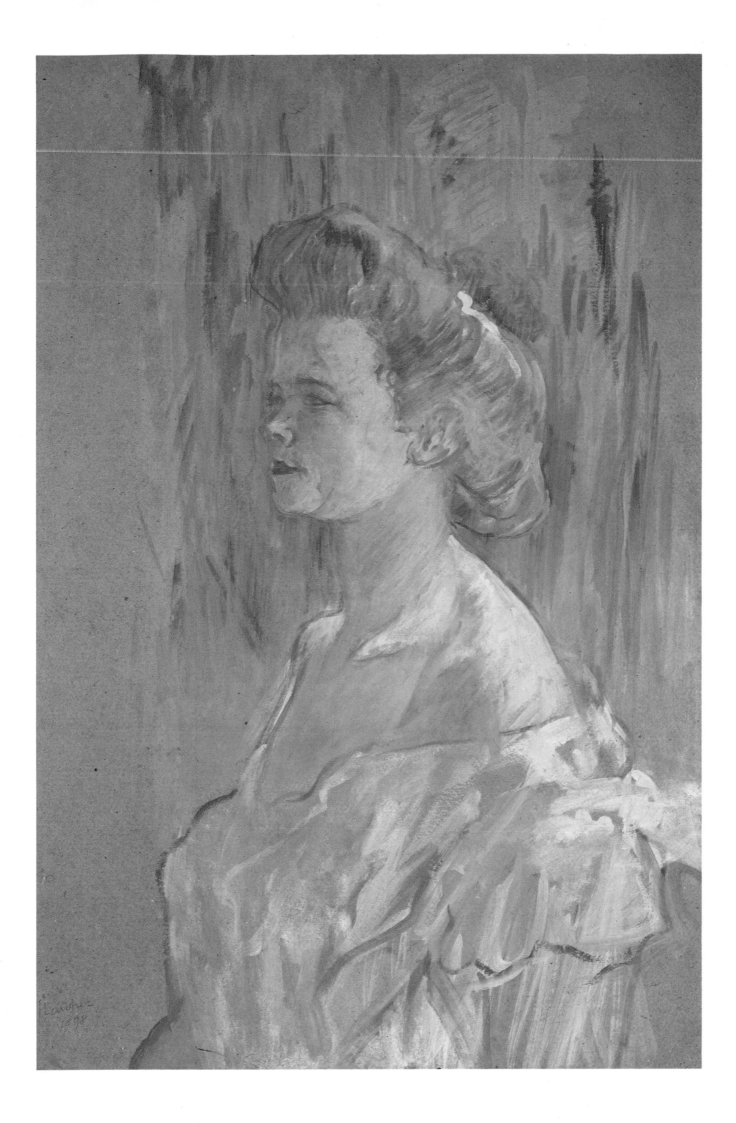

1896. Lithograph from 'Elles', 40 x 52 cm.

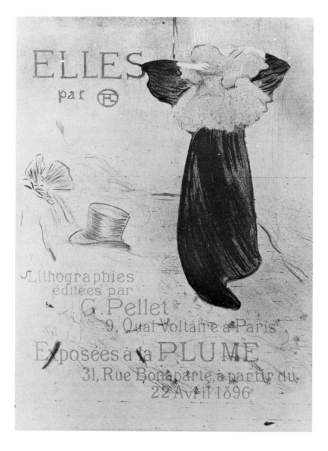

Fig. 34
'Elles'
(Advertisement
poster for the
album)

1896. Coloured lithograph,
61 x 48 cm.

The series of lithographs entitled *Elles*, which shows the life of the brothel and its inhabitants, is one of Lautrec's major achievements. There were ten lithographs in the set and it was published in 100 copies only. Even though the moral climate in Paris during the 1890s was far more liberal than the climate in London, it was still an extraordinarily daring subject to choose. When Lautrec held an exhibition in 1896, the year the prints were published, the brothel scenes were included, but were kept in a locked room, away from the general public. Lautrec himself used to drive away those whom he thought were merely curiosity seekers. Nevertheless, such works played a considerable part in creating the ambiguous reputation he enjoyed in his own lifetime – collectors, even the most advanced of them, found it difficult to take him seriously. Yet the brothel scenes now appear to us his most genuinely moralistic works – an indictment, not a sentimentalization, of organized prostitution.

1897. Lithograph, 48.5 x 36 cm.

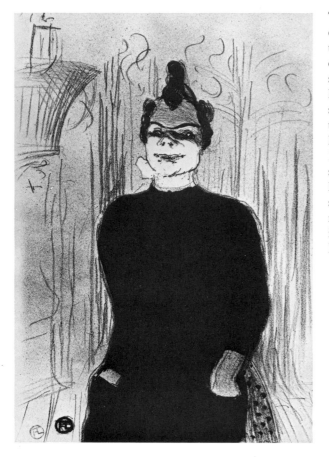

Fig. 35
At the Gaiété-
Rochechouart:
The Actress
Nicolle as a
Streetwalker

1893. Lithograph,
37 x 26 cm.

The establishment in the Rue des Moulins catered for all tastes, and no doubt was careful to provide a wide range of physical types for the delectation of its customers. Elsa, with her small features, scanty hair and smooth egg-shaped head, seems to foreshadow the 1920s – and in fact the clothes she is wearing also seem to give a glimpse of what women's fashions will be like just over two decades later. This may be coincidence, but there is something about the design which is even more fascinating – its likeness to the portrayals of fashionable women which were soon to be made by the leading figure in the Vienna Secession, Gustav Klimt. This portrait, like *The Sphinx* (Plate 43), which shows another woman from the same *maison*, seems to be Lautrec's version of a literally 'fatal' woman, and thus links him to the general *fin-de-siècle* context, more visible as a general rule in his social contacts – for example with the Natansons and the artistic circle surrounding the *Revue Blanche* – than in his actual work, with its strongly realistic bias. Elsa's elegance is doubly paradoxical if we compare it to Lautrec's portrait of an actress taking the role of a streetwalker (Fig. 35).

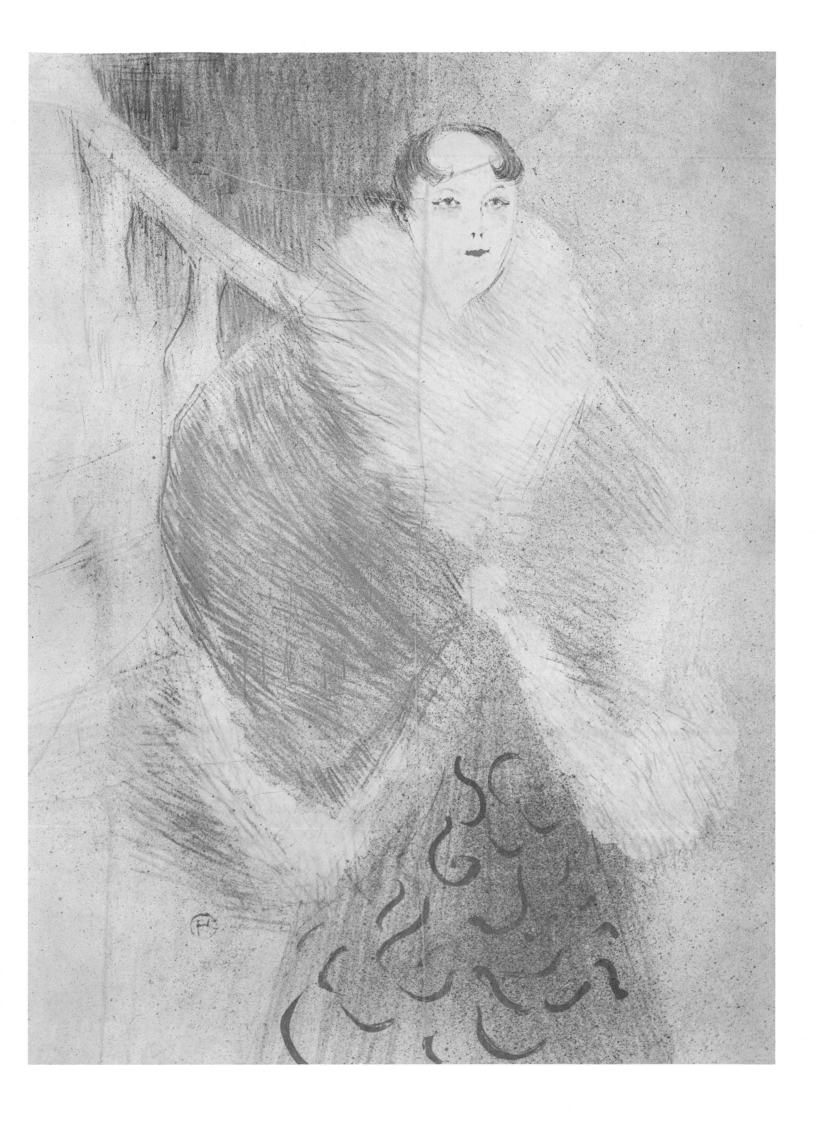

1895. Canvas, 54.5 x 45 cm. Courtauld Institute Galleries, London

The setting for this seems to be 'Le Rat Mort' in the Place Pigalle, a favourite haunt of the Australian artist Conder. Conder himself may well have posed for the blond man whose face is half-hidden. The female figure was modelled by Lucy Jourdain. Here again we see Lautrec rehandling a theme borrowed from Degas. Other attempts at it reproduced in this book are *A la Mie* (Plate 8) and *In the Bar* (Plate 42). Here the device Degas invented – that of pushing the male figure almost entirely out of the composition – is copied directly. Lautrec varies Degas's original idea by moving the viewpoint much closer, so that there is a less complicated spatial and psychological interplay and a much greater concentration on the woman herself. Daringly, though her face is the centre picture and its apparent point, he makes it almost abstract, a blur of colour and light characterized chiefly by the full red mouth which breaks into a sensual smile.

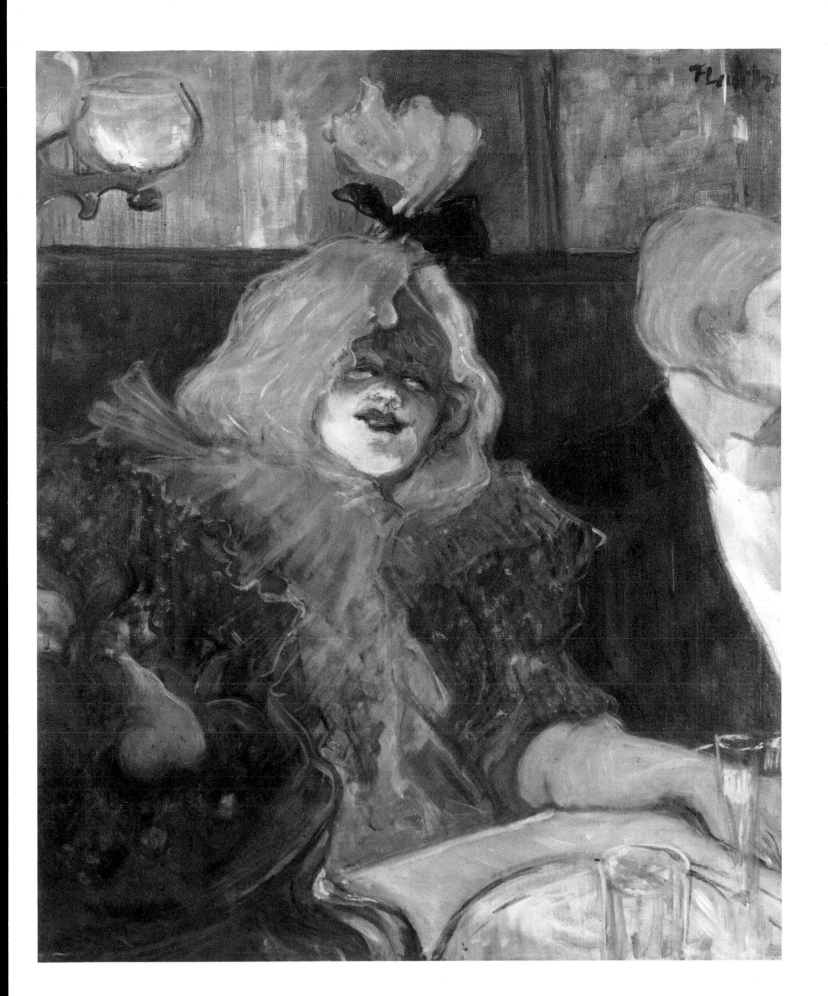

The English Girl from the 'Star' at Le Havre

1899. Wood, 41 x 33 cm. Musée Toulouse-Lautrec, Albi

Lautrec discovered the 'Star' and its English barmaid, Miss Dolly, when he was on his way to Taussat by sea. He had fairly recently been released from the asylum in Neuilly where he had been confined with a bout of delirium tremens, and the 'Star', which had a bad reputation, was perhaps the last place he should have frequented. It was virtually an English pub on French soil, filled chiefly by the English sailors who visited the port. Lautrec was much taken by Miss Dolly's health and good looks – and also by her flirtatious cheekiness – and turned her into one of the last of his major enthusiasms, making this portrait and some sketches of her singing sea-shanties with the sailors. Despite his failing health he has here managed to produce one of the most relaxed and charming of all his female portraits, with no visible element of caricature. Lautrec was very disappointed when he returned to Le Havre the following year and found the place closely watched by the police, with Miss Dolly absent and all its atmosphere departed.

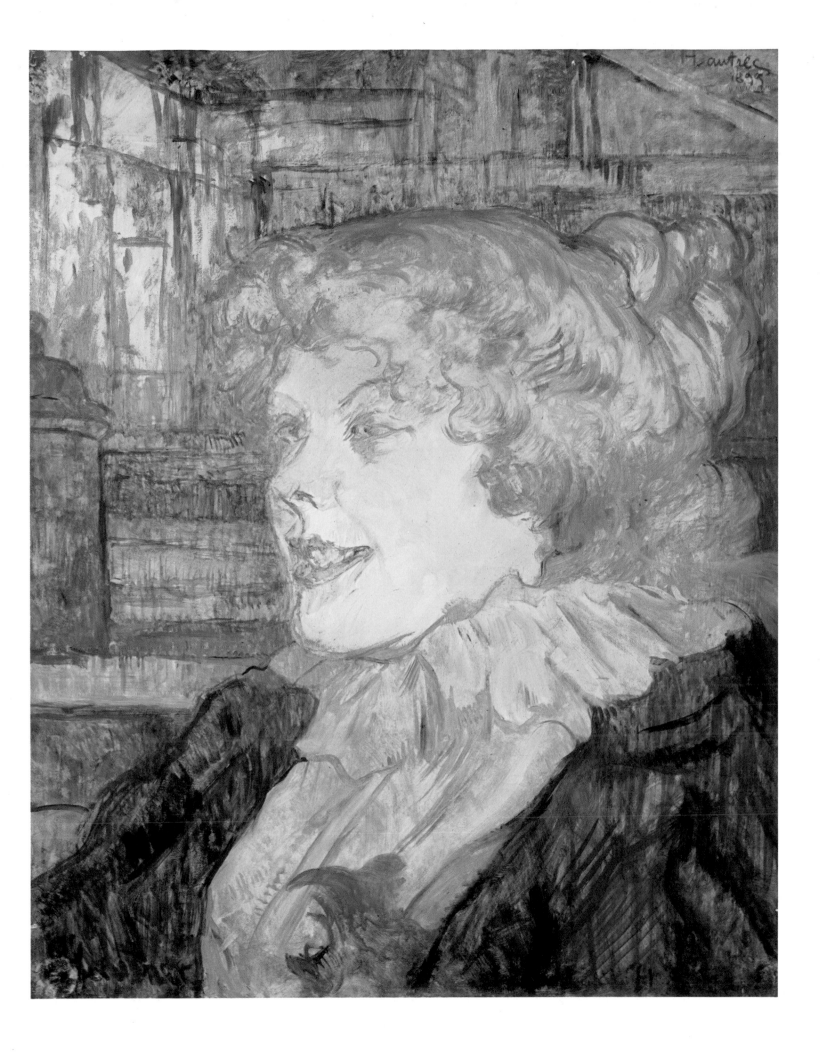

1900-1. Canvas, 100 x 73 cm. County Museum of Art, Los Angeles

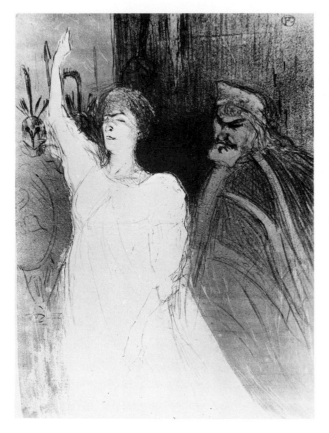

The six scenes from Isidore de Lara's 'Messaline', which was played at the Grand-Théâtre Bordeaux, are Lautrec's last major effort as an artist. He seems to have particularly relished the absurdity of classical scenes as they were represented on the contemporary stage – the plump Roman soldier in the foreground is a good example of the way in which they appealed to his sense of humour. The work based on 'Messaline' shows an abrupt change of style, with much less emphasis on drawing, and many large areas of flat colour – for example, here, the bright red dress which Messaline herself is wearing. It looks as if Lautrec was not trying to carry over into his paintings the style he had evolved for his posters. Unfortunately, compared to his best theatrical representations (Fig. 36) the result is heavy and stodgy, though it does show the way in which overblown classicism on the stage always tickled his fancy. The general verdict of art-historians has been that these final paintings show Lautrec in steep decline, possessed of only a shadow of his former gifts.

Fig. 36
Bartet and
Mounet-Sully
in 'Antigone'
(Comédie-
Française
production)

1894. Lithograph,
46 x 27 cm.

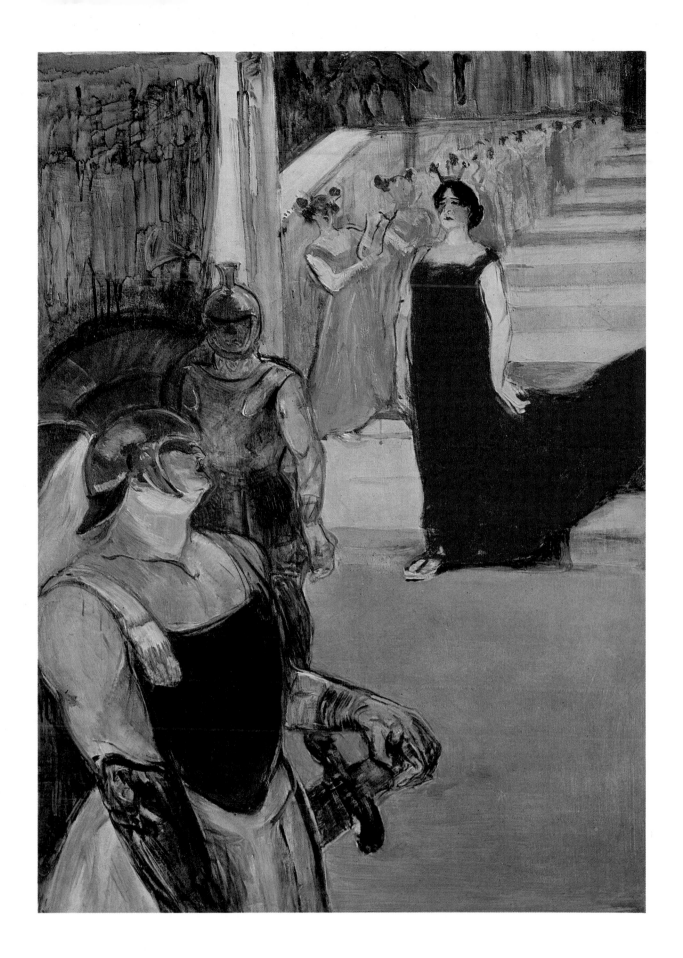

PHAIDON COLOUR LIBRARY
Titles in the series

FRA ANGELICO
Christopher Lloyd

BONNARD
Julian Bell

BRUEGEL
Keith Roberts

CANALETTO
Christopher Baker

CARAVAGGIO
Timothy
Wilson-Smith

CEZANNE
Catherine Dean

CHAGALL
Gill Polonsky

CHARDIN
Gabriel Naughton

CONSTABLE
John Sunderland

CUBISM
Philip Cooper

DALÍ
Christopher Masters

DEGAS
Keith Roberts

DÜRER
Martin Bailey

DUTCH PAINTING
Christopher Brown

ERNST
Ian Turpin

GAINSBOROUGH
Nicola Kalinsky

GAUGUIN
Alan Bowness

GOYA
Enriqueta Harris

HOLBEIN
Helen Langdon

IMPRESSIONISM
Mark Powell-Jones

**ITALIAN
RENAISSANCE
PAINTING**
Sara Elliott

**JAPANESE
COLOUR PRINTS**
J. Hillier

KLEE
Douglas Hall

KLIMT
Catherine Dean

MAGRITTE
Richard Calvocoressi

MANET
John Richardson

MATISSE
Nicholas Watkins

MODIGLIANI
Douglas Hall

MONET
John House

MUNCH
John Boulton Smith

PICASSO
Roland Penrose

PISSARRO
Christopher Lloyd

POP ART
Jamie James

**THE PRE-
RAPHAELITES**
Andrea Rose

REMBRANDT
Michael Kitson

RENOIR
William Gaunt

ROSSETTI
David Rodgers

SCHIELE
Christopher Short

SISLEY
Richard Shone

**SURREALIST
PAINTING**
Simon Wilson

**TOULOUSE-
LAUTREC**
Edward Lucie-Smith

TURNER
William Gaunt

VAN GOGH
Wilhelm Uhde

VERMEER
Martin Bailey

WHISTLER
Frances Spalding